Rubens Unveiled

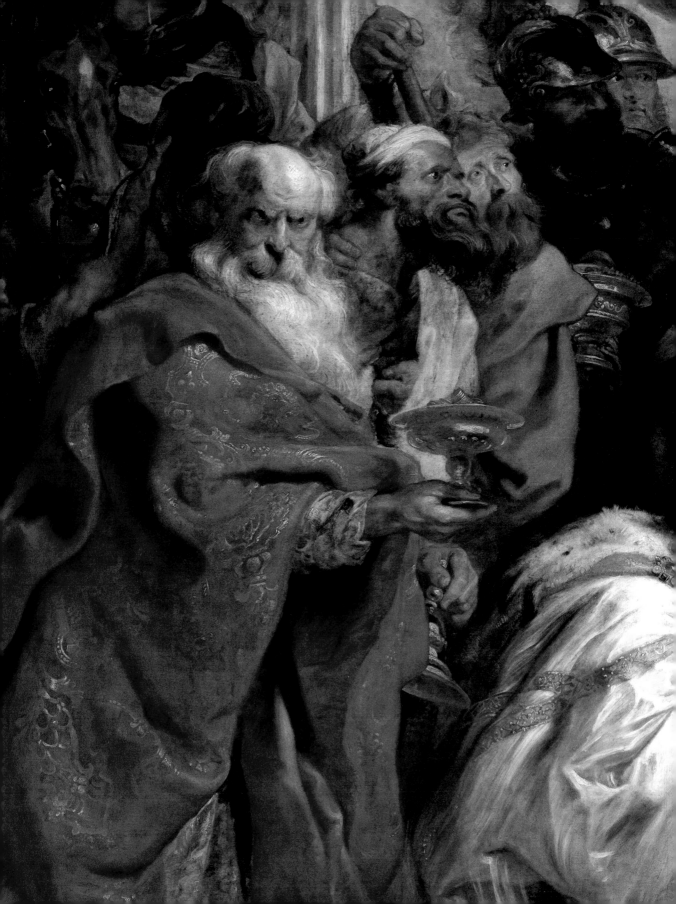

Rubens
Unveiled

Paintings from Lost Antwerp Churches VALÉRIE HERREMANS

snoeck

Koninklijk Museum
voor Schone Kunsten
Antwerp

*This book – the second volume in the series 'Rubens Unveiled' –
was published as part of the Rubens Research Project
led by Professor Arnout Balis on behalf of the Koninklijk Museum
voor Schone Kunsten, Antwerp, in association with the Centrum
Rubenianum and the Rubenianum (City of Antwerp).*

1007108344

Author
VALÉRIE HERREMANS

Reconstruction drawings
JORIS SNAET

Coordination
CHRISTINE VAN MULDERS

Translation
TED ALKINS

Editing and design
PAUL VAN CALSTER

Lithography
GBL Communication, Heule

Printed in the European Union.

Copyright © 2013 Koninklijk
Museum voor Schone Kunsten,
Antwerp, and the author

www.snoeckpublishers.be
ISBN 978-94-6161-134-5
D/2013/0012/63

Cover:
Peter Paul Rubens,
Rockox Triptych, 1613–15
(detail of fig. 40).
Koninklijk Museum voor Schone
Kunsten, Antwerp, inv. 307–11

Frontispiece:
Peter Paul Rubens,
The Adoration of the Magi, c. 1624
(detail of fig. 87).
Koninklijk Museum voor Schone
Kunsten, Antwerp, inv. 298

CONTENTS

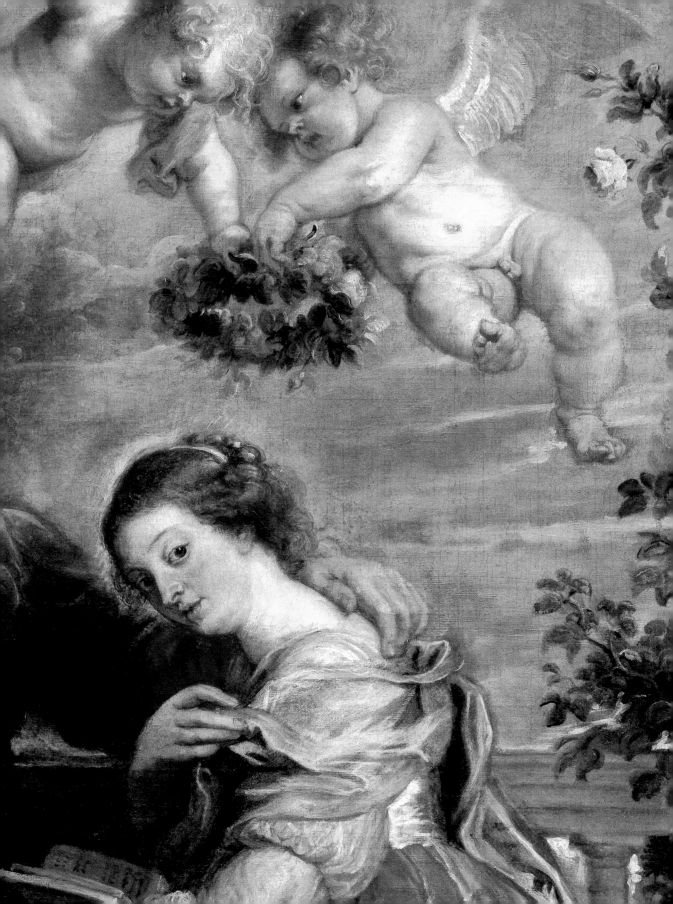

The late Ger Schmook, historian, writer and director of the Antwerp municipal libraries, made a fascinating contribution in the early 1940s to the historiography of our museum's collection. Through the mouth of 'Teun den Eyerboer' [Teun the Egg Seller], he described with gusto the triumphant return in 1815 of art treasures looted from the city's churches and monasteries during the French Revolution.[1]

The account of this celebrated act of restitution centres on the Rubenses that had been the pride of Antwerp churches in the *ancien régime*. The works were painted specifically for these institutions and were an integral part of their interiors. Some were reinstalled at their original locations – among them the *Assumption of the Virgin* and the commemorative paintings in the cathedral, the *Virgin and Child with Saints* in Rubens's burial chapel at St James's, and the Rubenses in St Paul's Church. In most cases, however, this was not possible, as the sites for which the paintings had been made no longer existed or had lost their original function. Such was the fate of the Friars Minor Church on Mutsaardstraat, the Abbey Church of St Michael on Kloosterstraat, the Calced Carmelite Church off the Meir, and the Church of the Discalced Carmelites, on what is now Graanmarkt.

A new home was therefore needed for these orphaned works of art, which they duly found in the museum of the Royal Academy. However, they no longer served here as religious objects, but as exemplars of the art of a glorious past, and teaching materials for successive generations of art students. In assuming the status of museum pieces, the paintings had to relinquish the authentic context in which they had originally functioned and related to one another. The connection with the architectural settings for which they were created and the social significance associated with them was severed, never to be repaired.

Those original settings and relationships are the subject of this book. Virtual reconstructions are provided of the four lost churches, offering us a fresh and surprising look at several outstanding works from the Antwerp museum's collection. The publication is the culmination of research carried out by the museum team as part of our Rubens Project, in which all the Rubens paintings in our collection are being 'unveiled'. Alongside a thorough technical study – covered in an earlier publication[2] – we have scrutinized the cultural and historical context in which they were created. Credit for this goes to my colleague Dr Valérie Herremans, whose expertise in the field of sculpture and altarpieces has enabled us to situate the Rubenses and other works in their original settings once more. The painstaking spatial reconstruction of these former sites will help you follow her absorbing story.

Our aim has been to present you with a book that is attractive, pleasant to handle, and above all a compelling read. I am sure you will enjoy it.

Dr Paul Huvenne
General Director, Koninklijk Museum voor Schone Kunsten, Antwerp

7

1 Ger Schmook, *Hoe Teun den Eyerboer in 1815 sprak tot de burgers van Antwerpen, of Het aandeel van de Rubens-viering in de wording van het Vlaamse bewustzijn*, Antwerp 1942.
2 Nico Van Hout and Arnout Balis, *Rubens Unveiled: Notes on the Master's Painting Technique*, Antwerp 2012.

Peter Paul Rubens
The Education of Mary, c. 1630–35
(detail of fig. 136).
Koninklijk Museum voor Schone Kunsten,
Antwerp, inv. 306

Introduction

The paintings of Peter Paul Rubens form the very essence of the Koninklijk Museum voor Schone Kunsten in Antwerp. At the time of writing, the museum is undergoing major renovation and so the works are not currently hanging in their usual home, the Rubens Room. But when they do, they function as the beating heart of the institution, at its very centre. Rubens's works form the basis of the museum collection in figurative terms as well, albeit together with a number of other paintings.

THE RUBENS COLLECTION OF ANTWERP'S KONINKLIJK MUSEUM VOOR SCHONE KUNSTEN

How did these paintings come to be in the Koninklijk Museum? To answer that, we have to go back to the turbulent end of the eighteenth century. The countless reforms introduced by Emperor Joseph II of Austria, who succeeded Maria Theresa in 1780, eventually drove the much-provoked Low Countries to rise in rebellion in 1789. The resultant 'United States of Belgium' proved extremely short-lived, with a first Austrian restoration as early as the autumn of 1790. The territory was then briefly annexed by France in 1792–93. Following their victory at the Battle of Fleurus on 26 June 1794, however, French revolutionary troops finally conquered the Austrian Netherlands, which were absorbed into the French Republic on 1 October 1795. The introduction of the new Napoleonic constitution put an end to the privileged position enjoyed by the clergy. What is more, to raise money for the state, the French regime – the Directoire – promulgated a law on 1 September 1796 under which churches and abbeys were stripped of their property.

As far as the artistic possessions of the Antwerp churches and abbeys were concerned,

1 ▶▶

The Rubens Room in the Koninklijk Museum voor Schone Kunsten, Antwerp.

(left) *The Education of Mary* (partly visible; see fig. 136), *The Baptism of Christ*, *The Holy Trinity* (fig. 114); (rear wall) *Madonna Adored by Saints*; (right) *The Adoration of the Magi* (fig. 87), *The Last Communion of St Francis of Assisi* (figs. 3, 30), *The Coup de Lance* (figs. 36, 43). All these paintings – except the *Baptism of Christ* – came from Antwerp churches.

however, the axe had already fallen. The 'Comité de Salut public' had acted as early as 18 July 1794 to regulate the economic 'conquest' of the Low Countries. Taxes were set and the export was ordered of many valuable capital goods to France. Meanwhile, Jacques-Luc Barbier – artist and lieutenant in the 5th Hussar Regiment – was charged by the Convention with a special mission to draw up an inventory of all important paintings in Antwerp with a view to shipping them to Paris. French troops entered Antwerp on 24 July to execute the plan, to which end a series of churches was closed between 28 July and 9 August, followed by St Michael's Abbey and the Beguinage on 5 and 12 September. The confiscated works were assembled at St Michael's and boxed up ready for transportation. A first small consignment of four paintings by Rubens departed on 11 August 1794, including the *Coup de Lance* and the copy of the *Descent from the Cross*, both of which would ultimately join the collection of the Antwerp Museum.

A total of no fewer than sixty-six paintings were ultimately selected from the cathedral, the various abbey churches and St Luke's guildhouse. They included many works by Rubens, but also paintings by Anthony van Dyck, Jacob Jordaens, Abraham Janssen, Theodoor Boeyermans, Otto Venius, Frans Snyders and Cornelis de Vos. They arrived in the French capital in several batches by the end of the year and were placed in the Louvre.

Fortunately, it did not come to that for the remainder of Antwerp's movable heritage. The painter Willem Herreyns (1743–1827), director of the newly founded 'Ecole spéciale de Peinture, de Sculpture et d'Architecture', called successfully for the most valuable remaining works of art to be kept in the city, arguing that they would play a special role in artistic training and serve as examples for young artists. The French were threatening at this point to sell off the remainder of the

public art treasures as *mobilier national*. In the end, 328 paintings were selected and saved from that unfortunate fate. They were given a place in the newly founded museum of the 'Ecole centrale du Département des Deux-Nèthes', located since 1797 in the buildings of the suppressed Convent of the Discalced Carmelites. When the school was closed down in turn in 1802, the collection reverted to the state. In the meantime, the former Academy of Fine Arts had been re-established in the expropriated Abbey of the Friars Minor in 1804. This institution too had a museum, set up in the former abbey church. When the Franciscan abbey too was transferred to the City of Antwerp by imperial decree in 1810, the Ecole centrale's collection finally ended up there. The works were united with those belonging to the Academy, laying the foundation of what would later become the collection of the Koninklijk Museum.

The true highlights were, however, still in Paris and would remain there until after the defeat of Napoleon at the Battle of Waterloo in 1815, at which point their immediate return was demanded. The major works arrived back in Antwerp in December that same year and were also housed in the Academy's museum. Following a period of restoration, the masterpieces were exhibited to the public at the museum from 15 February 1816. A Royal Decree of 6 October 1815 allowed the churches that were still in religious use to claim back their precious paintings. The other works, a total of twenty-seven, remained in the museum where, together with the ones from the Ecole centrale, they formed the central corpus of the future Koninklijk Museum.

Masterpieces whose return was not claimed by the church councils included the Rubens works from abolished and expropriated abbey churches, which can be numbered among the most important in the Museum's current 40 collection. They are the *Rockox Triptych* (1613– 3,30 15), the *Last Communion of St Francis of Assisi*

3 ▶ 36, 43

Peter Paul Rubens 114, 87
The Last Communion
of St Francis of Assisi, 1619 134
(detail of fig. 30).
Koninklijk Museum voor Schone 2
Kunsten, Antwerp, inv. 305

Provenance: Friars Minor 26

(1619), the *Coup de Lance* (1619–20), the *Holy Trinity* (c. 1620), the *Adoration of the Magi* (1624), *St Theresa of Avila Interceding for Bernardino de Mendoza in Purgatory* and the *Education of Mary* (both 1630–35). There are also two undated works: *Christ on the Cross* and a small copy after the *Descent from the Cross* from the cathedral.

THE CHURCHES

Anyone looking at a seventeenth-century
4 map of Antwerp will be surprised by the large number of churches in the townscape. Although many remain to this day, a lot have also disappeared: both parish churches and those belonging to religious orders. Others were put to new use. Various abbey churches were taken over by parishes after the calamitous French period. The Dominican and Jesuit churches, for instance, are known today as St Paul's Church and St Charles Borromeo. In some cases, the repurposing occurred recently. The Augustinian Church in Kammerstraat was deconsecrated in the 1970s and became a centre for early music in 1999.

Several other abbey churches, however, fared less well and, following their confiscation in the French period and subsequent use as hospital, military depot, shipyard and museum, to name just a few, were eventually demolished. These former Antwerp abbey churches, which now live on only in the collective memory, include the four institutions whose paintings by Rubens form the nucleus of the Koninklijk Museum's collection. It is to them that this book is dedicated. They were the Norbertine or Premonstratensian St Michael's Abbey; the Franciscan Church; the Calced Carmelite Church and the Discalced Carmelite Church.

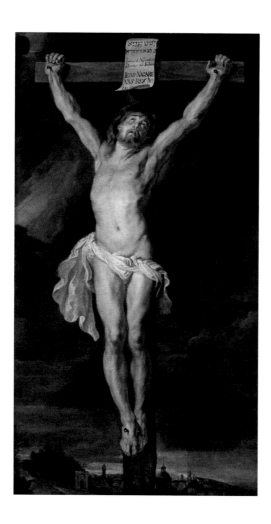

2

Peter Paul Rubens
Christ on the Cross, c. 1613.
Canvas, 221 × 122.5 cm.
Koninklijk Museum voor Schone Kunsten,
Antwerp, inv. 313

Provenance: Friars Minor

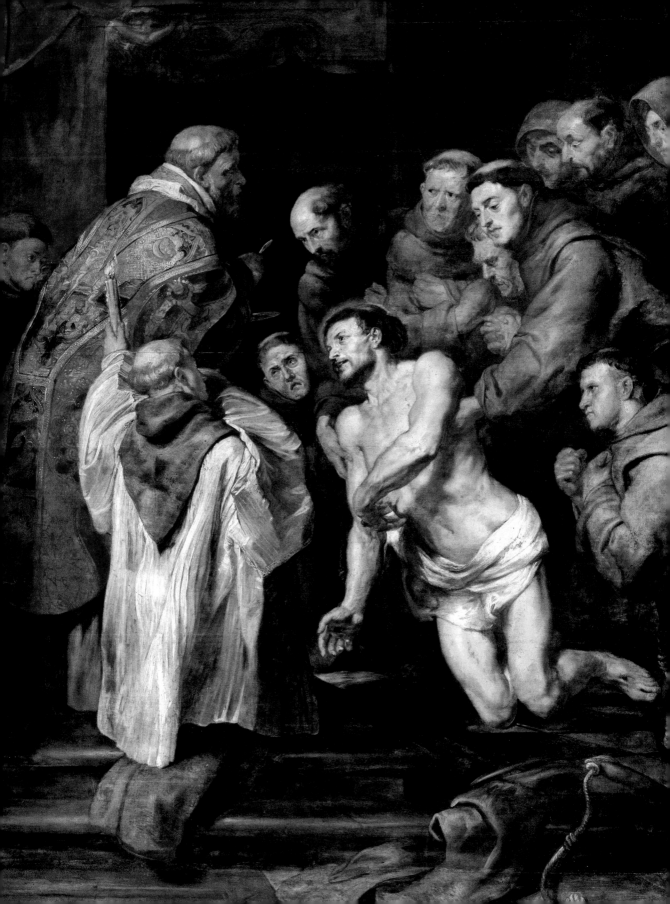

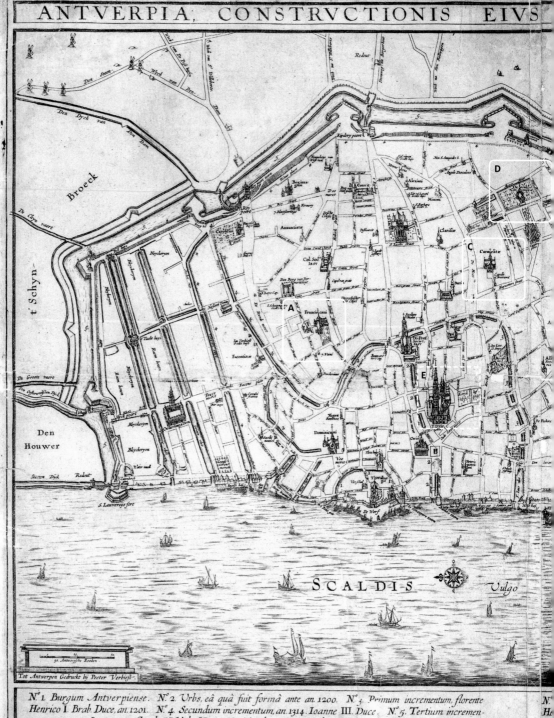

N.º 1. *Burgum Antverpiense.* N.º 2. *Vrbs, eâ quâ fuit formâ ante an. 1200.* N.º 3. *Primum incrementum, florente Henrico I. Brab. Duce, an. 1201.* N.º 4. *Secundum incrementum, an. 1314. Ioanne III. Duce.* N.º 5. *Tertium incrementum, an. 1543. Imperante Carolo V. Vrbe Noua. Munitionibusǫ; Nouis inibi comprehensis.* N.º 6. *Quintum incrementum Castro constructo, et eius Areâ interiectâ. an. 1567. Regnante Philippo II.*

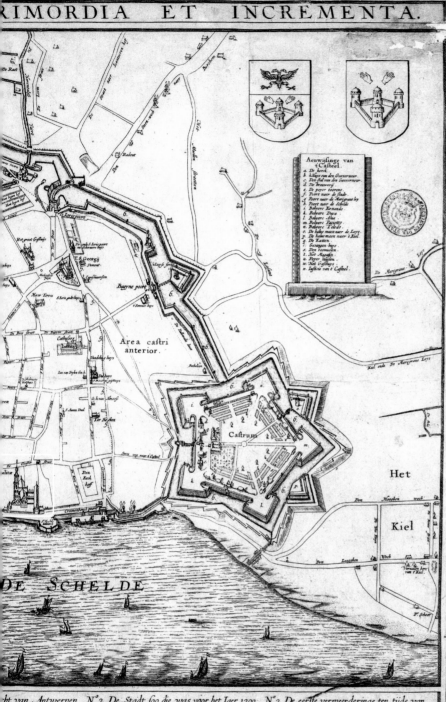

4

Pieter Verbiest II
Map of Antwerp:
*Antverpia constructionis eius
primordia et incrementa*, c. 1662.
Engraving, 490 × 675 mm.
FelixArchief, Antwerp, inv. 12 5832

The map shows all Antwerp churches
and convents that are discussed or
mentioned in this book.
A Friars Minor
B St Michael's Abbey and Church
C Calced Carmelites
D Discalced Carmelites
E Our Lady's Cathedral

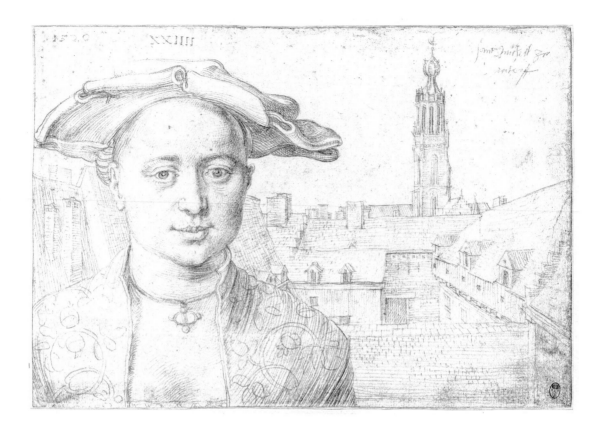

45 The twelfth-century **St Michael's Abbey** was undoubtedly the most venerable of the four institutions. It belonged to the Premonstratensians or Norbertines – an order of canons regular, which means it had both an active and a contemplative dimension. On the one hand, its members were clerics, mostly priests, while on the other, they lived in a community that followed a monastic rule. In the case of the Norbertines, this was the Rule of St Augustine. They lived under the spiritual leadership of a prelate, the abbot or prior. Norbertine communities were based in abbeys or priories and could also include lay brothers, who generally took care of the practical, worldly tasks.

Premonstratensian spirituality is characterized by five specific goals: celebrating the choral office or religious service of God; the care of souls; doing penance; and special devotion to the Holy Sacrament and to the Virgin Mary. The second goal, the spiritual welfare of lay people, was expressed in the fact that, as priests, the canons could serve the many parishes over which their abbeys held 'rights'. Not only did these parishes provide the abbeys with the necessary income in the shape of tithes, the Norbertines were also intensively occupied there with spiritual care.

The Norbertines were named for their
7 founder, St Norbert, who in 1120 established the order's first community at Prémontré, near Laon in northern France. Norbert came from Xanten, on the banks of the Rhine in what is now North Rhine-Westphalia, where he became a canon. The rule followed by his chapter allowed private possessions and Norbert himself was a member of the high nobility. He underwent a kind of conversion around 1115, following which he turned his

back on the wealthy and worldly life led by the members of his chapter and embarked on an itinerant existence as preacher, wandering through France with a small group of followers. The foundation at Prémontré followed some time later in consultation with the Bishop of Laon. The members of the community took their vows at Christmas 1121 and adopted the Rule of St Augustine. So it was that the Premonstratensian Order was born.

A few years later, Norbert visited Antwerp to tackle adherents of the doctrine of the heretic Tanchelm (or Tanchelin), by then deceased. Tanchelm and his followers believed, among other things, that the Transubstantiation – the transformation of the bread and wine into the body of Christ during the mass – did not occur if the service was performed by 'unworthy' priests, including ones who were married. Despite the widespread existence of this 'aberration' (known as 'Nicolaism') the pro-papal reformer Norbert could not tolerate such Eucharistic heresy. St Michael's Abbey was founded in 1124, during this mission.

The second oldest of the churches was that of the **Franciscans** or **Friars Minor**, founded in the mid-fifteenth century. The Friars Minor were a very different order from the Norbertines. They were one of the medieval mendicant orders that arose in the thirteenth century, so called because members took a vow of poverty. Neither individual friars nor their communities were supposed to have any material possessions, and they relied on charity for their living.

According to tradition, the Franciscan Order – *Ordo Fratrum Minorum* – was founded by its namesake Francis of Assisi (1181/82–1226) on 16 April 1209 in the central Italian region of Umbria. The followers of St Francis rapidly spread across Europe. The house of the Friars Minor in Antwerp was founded in 1446 by 'Observants' – members of a reform movement, who were highly critical of the wealth of the abbeys and sought to re-establish the ideal of poverty. The foundation boasted an important patron, Philip the Good (1396–1467), Duke of Burgundy, who is therefore referred to in the abbey's chronicle as *archifundator* or 'archfounder'.

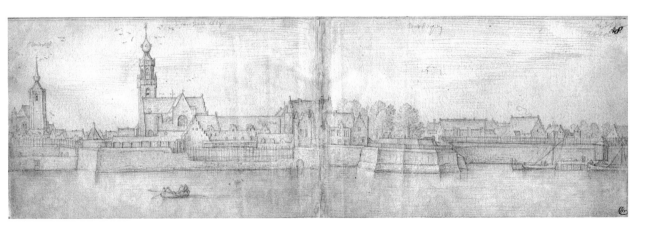

◄ 5

Albrecht Dürer
Portrait of an unidentified sitter with St Michael's Abbey in the background, 1520.
Drawing, 130 × 190 mm.
Musée Condé, Chantilly, inv. DE 892
St Michael's Abbey from the south.

6

Hans Bol
View of St Michael's Abbey from the Left Bank of the Scheldt, 2nd half 16th century.
Drawing, 129 × 405 mm.
The British Museum, London,
inv. AN 182018

7

Cornelis de Vos
*The Citizens of Antwerp Bringing the Monstrance
and Sacred Vessels Hidden from Tanchelm
to St Norbert*, 1630.
Canvas, 153 × 249 cm.
Koninklijk Museum voor Schone Kunsten,
Antwerp, inv. 107

Provenance: St Michael's Abbey.
In the background of this epitaph of Nicolaes
Snoeck are the towers of St Michael's Abbey and the
Cathedral, seen from the south.

8 ▶

Abraham Janssen
The Lamentation of Christ, c. 1624.
Canvas, 155 x 180.5 cm.
Muzeum Narodowe, Warsaw

Provenance: Friars Minor

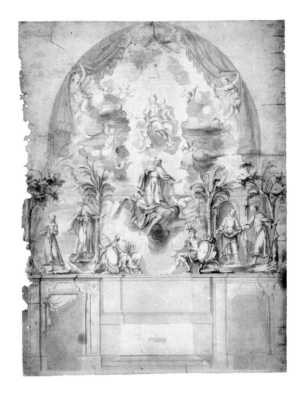

9

W. I. Kerrickx
*Temporary festive decoration of
the high altar of the Friars Minor Church.*
Drawing. Museum Plantin-Moretus/
Prentenkabinet, Antwerp, inv. CVH 177

The third church we look at in this book was built from the end of the fifteenth century onwards by another mendicant order, the

10 **Carmelites**. They traced their roots back to the age of the prophets Elijah and Elisha, whom they considered to be their order's founders. The Carmelites originated geographically at Mount Carmel, near the city of Haifa in what is now Israel. Hermits had long taken themselves up into the mountain to devote their lives to God. The introduction of a monastic rule in the thirteenth century transformed them into a mendicant order, but also saw the community driven away from Mount Carmel itself by the Saracens. It was at this point that the order began to spread across Europe. They called themselves the 'Brothers of Our Lady of Mount Carmel', after the Chapel of Our Lady founded on the mountain by the original hermits.

St Simon Stock, general of the order between 1245 and 1265, played an important part in its development. He set out to found as many abbeys as possible in university towns to help raise the intellectual level of the novices. The Carmelite Rule was originally very strict – more so than that of other mendicant orders like the Franciscans and Dominicans – and some members sought to have it mitigated, giving rise over time to fierce disputes within the order. As was the case with all the mendicant orders, infractions of the rule became increasingly frequent as the fourteenth century progressed and created a need for reform. The most successful attempt to do this gave rise to a new order: the Discalced (barefoot) Carmelites, causing the older branch of the order to be referred to henceforward as the Calced (shod) Carmelites.

11 The **Discalced Carmelites** founded the final church discussed in this book. It was only established in the seventeenth century, making it substantially more recent than

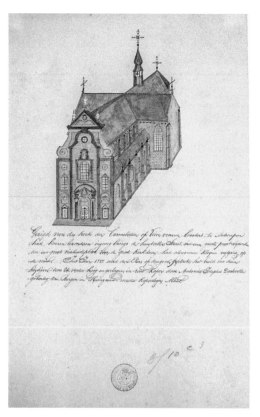

10
Anonymous
*The Church of the Calced Carmelites
from the west*, after 1737.
Watercolour.
FelixArchief, Antwerp, inv. 12 5320

10
Anonymous
*The Church of the Calced Carmelites
from the west*, after 1737.
Watercolour.
FelixArchief, Antwerp, inv. 12 5320

11
Anonymous
*The Church of the Discalced
Carmelites from the west*.
Drawing.
FelixArchief, Antwerp

the other three. Unlike their older, 'shod' counterparts, the Discalced Carmelites were a 'young' order that only emerged in the sixteenth century following the reforms inspired by St Theresa of Avila in collaboration with St John of the Cross. They sought to restore a stricter application of Carmelite ideals, the foundations of which were poverty, seclusion and prayer. A separate province for the new observance was created in 1580, followed by a separate congregation in 1587. On 20 December 1593, the new order was born. The Belgian province was created in 1617. The first male houses in the Southern Netherlands, including the one in Antwerp, were founded by the order's Italian congregation, which was granted permission by the ecclesiastical and political authorities to settle in Antwerp in 1618, having founded a first house in Brussels in 1610. It took until 1624 to obtain a parcel of land (1.3 hectares) between Hopland, Graanmarkt and Vaartstraat, large enough to allow the community to build its abbey.

Different types of source exist for each of our four abbey churches, enabling us to reconstruct their appearance, both exterior and interior. In addition to the works of art with which they were decorated, including the paintings by Rubens, these sources include literary descriptions, maps and city views, plans and elevations, archival records and views of their interiors. Armed with this information, our book aims to bring the historical context of Rubens's works to life. A description of these churches, abundant illustrations and detailed reconstruction drawings will provide the reader with an extremely concrete picture of the original setting of these masterpieces. The paintings' current home, the museum environment of the Koninklijk Museum, emphasizes their artistic and art-historical value. The aim of this book, by contrast, is to give the reader a renewed sense of their significance in other

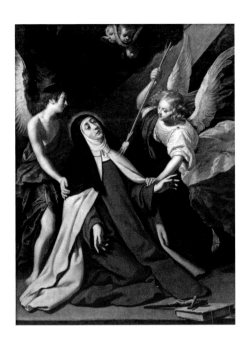

12

Gerard Seghers
The Ecstasy of St Theresa.
Canvas, 264 × 195 cm.
Koninklijk Museum voor Schone Kunsten,
Antwerp, inv. 509

Provenance: Discalced Carmelites

respects. By putting the paintings back in their original location, we gain not only an insight into their material context, but also clues as to their intangible context. What motivated their patrons? What place did the works occupy in seventeenth-century painting and church design, in Rubens's oeuvre and in the visual tradition of the relevant religious order?

THE PATRONS

The works of art discussed in this book were intended for four Antwerp minsters, and so one might reasonably assume that they were commissioned by the relevant religious orders themselves. It may come as a surprise therefore to learn that this was only the case for one of them – the painting for the high altar of St Michael's. The majority were not funded by the institutions in which they were displayed but by private individuals. Several explanations can be offered for this. Firstly, three of the orders to which our churches belonged were mendicants – Friars Minor and

Calced and Discalced Carmelites – who relied on gifts and endowments for their material support. Another key factor, which was also extremely important beyond this specific context, was the fine balance between the material needs of the ecclesiastical authorities and the spiritual and social aspirations of wealthy worshippers. The churches were in desperate need of financial support in the early seventeenth century, due in part to the destruction wrought during the 'Iconoclastic Fury' of 1566 and the stripping of church interiors during the period of Calvinist rule in the final decades of the sixteenth century. Protestant reformers took great exception to images of holy figures, which they removed from churches, sometimes violently. There was a need, therefore, to restore Catholic buildings damaged in this way.

At the same time, the renewal of the Catholic Church in response to the Reformation brought with it new material needs. Not only were new church fixtures such as confessionals now required, the artistic decoration of church interiors had

to be aligned with the new priorities. Such decoration offered a perfect opportunity for the visual communication of Catholic doctrine through imposing painted and carved images.

A further dynamism arose in cities like Antwerp due to the high concentration of religious institutions, each of which took up its position in the urban 'piety market'. The influence of new and ambitious orders like the Jesuits, who did not hesitate to deploy artistic splendour in their 'battle', ought not to be underestimated. Their marble temple with its sumptuous interior caused a huge stir, prompting the other orders to cast around for an appropriate response.

Vast amounts of money were needed to fund these decorative schemes, which ecclesiastical institutions did not have at their disposal, the mendicants least of all. The Antwerp Jesuits' magnificent new church had taken them to the brink of bankruptcy. Eyes therefore turned to wealthy members of the congregation, who had needs of their own, albeit of a very different, spiritual and social, nature. Rich Antwerp citizens were concerned, like all Christians, with the salvation of their souls – their future in the afterlife and more specifically the amount of time they would have to spend in purgatory. Their material status provided them with several possibilities to promote that salvation while still alive that were not shared by the less well-off.

Catholicism extended the traditional interpretation of *caritas* – giving alms to the needy – to include foundations or donations to churches by wealthy believers. In return the church would celebrate a specific number of masses for their soul. The endowment could also take the form of a contribution to the physical fabric of the church, an investment that would benefit the general interest. Moreover, the belief was propagated that the founder of an image of a saint could count on the latter's intercession or mediation which, like masses for the soul, could favourably

influence the amount of time spent in purgatory.

In addition to the spiritual dimension, these foundations – of chapels, altars, furnishings and works of art – had an important social function. As a conspicuous demonstration of wealth, they enabled the families in question to position themselves within the urban elite. Endowments were also important, therefore, in terms of prestige. To lay claim to this form of sponsorship *avant la lettre*, the identity of the donor had to be made clear. And what better way than a portrait? Donors' portraits had thus long been incorporated in the paintings they presented, even when these were not primarily intended as commemorative. Precisely this, however, had become an issue by the early seventeenth century.

The many paintings and sculptures decorating Catholic churches were a key point of controversy during the religious conflicts of the sixteenth century. According to Protestants, the honour that Catholics afforded to such images amounted to pure idolatry. The Council of Trent, which was convened by the Catholic authorities to decide on internal reforms in response to such criticisms, reiterated the Church of Rome's centuries-old view that images of saints were an essential element of Catholic religious practice: it was not the image itself that was being venerated, but the saint to whom the image referred. At the same time, however, there was an insistence on greater control of the way holy figures were represented, to avoid 'unseemly' images. This control was to be exercised in the first instance by the local bishop, even in churches not under his direct authority.

A number of provincial councils and diocesan synods were held in the Southern Netherlands to discuss the application of the new regulations. It was decided at the provincial council in 1607 that depictions of living people – in other words, donors'

portraits – would henceforth be prohibited on the 'innermost paintings of altars'. This referred to the open wings and central panel of the triptychs that were still such popular altarpieces at the time. The custom of incorporating donor figures in such scenes was criticized, as it was now felt to be inappropriate for a sacred image destined for an altar. This guideline on the use of portraits is one of the few specific elaborations in the general disciplinary framework sketched out by the Council of Trent.

The decrees of the synod held in the diocese of Antwerp in 1610, however, include two further concrete guidelines: 'depicting the supper of Our Lord as a Calvinist meal, that is to say, with elongated pieces of bread laid on a dish, or with pieces of bread soaked in red wine. Anywhere such images are found, they must be immediately corrected or wholly removed.' And: 'Images of the crucified Christ must be depicted as bloody and with blue welts from the beating, so that the price of our Salvation is more clearly expressed.' It was further ordered that any 'new or unusual' depiction required the approval of the bishop, the vicariate general and the chapter, or – in rural areas – the dean. The Antwerp donors of the altarpieces and commemorative paintings we will explore in this book had to take account of these clear ecclesiastical injunctions.

2

LITERATURE

S. Beele, G. Van Broeckhoven, B. Caen et al., *Het Koninklijk Museum voor Schone Kunsten Antwerpen: een geschiedenis 1810–2007*, Oostkamp 2008.

P. F. X. De Ram, *Nova et absoluta collectio synodorum tam provincialium quam dioecesanarum archiepiscopatus Mechliniensis* (*Synodicon belgicum sive acta omnium ecclesiarum Belgii a celebrato concilio tridentino usque ad concordatum anni 1801*), vol. 2, Leuven 1828–29.

P. F. X. De Ram, *Nova et absoluta collectio synodorum episcopatus Antverpiensis …* (*Synodicon belgicum sive acta omnium ecclesiarum Belgii a celebrato concilio tridentino usque ad concordatum anni 1801*), vol. 3, Leuven 1858.

V. Herremans, '*Ars longa vita brevis*. Altar Decoration and the Salvation of the Soul in the Seventeenth Century', *Jaarboek Koninklijk Museum Antwerpen*, 2010, pp. 85–111.

A. Monballieu, 'Het probleem van het portret bij Rubens' altaarstukken', *Gentse Bijdragen tot de Kunstgeschiedenis en Oudheidkunde* 24 (1976–78), pp. 159–168.

B. Timmermans, *Patronen van patronage in het zeventiende-eeuwse Antwerpen: een elite als actor binnen een kunstwereld*, Amsterdam 2008.

J. van den Nieuwenhuizen, 'Antwerpse schilderijen te Parijs (1794–1815)', *Antwerpen: Tijdschrift der Stad Antwerpen* 8 (1962), 2, pp. 66–83.

The Church of the Friars Minor Recollects

The centuries-old Franciscan Church is the
4 only one in this book located north of the
cathedral. It stood on the present site of the
Koninklijke Academie voor Schone Kunsten
(Royal Academy of Fine Arts). The abbey of
which the church was part was situated on
Raamveld: a parcel of land now enclosed by
Mutsaardstraat, Blindestraat, Venusstraat
and Stadswaag. The construction of the city
weighhouse (*stadswaag*) in 1547 was the trigger
for major changes in the district. The project
was the brainchild of the prominent town
planner Gilbert van Schoonbeke (1519–1556),
who was the weighmaster as well as a property
developer and entrepreneur. As such, he
was well aware that the existing weighhouse
was no longer fit for purpose in the rapidly
developing city. The enterprising Schoonbeke
offered to build a new one at his own expense,
in return for the civic authorities giving him
several pieces of publicly owned land around
Varkensmarkt. The contract was signed on
14 March 1547.

Schoonbeke laid out a new plaza on the
site of the Eeckhoff, the wooden former
city storehouse, and constructed the new
weighhouse in the middle. He then laid
several streets around it, so that goods that
had to be weighed for municipal taxation
could be readily transported there. Numerous
warehouses and residences for – mostly
foreign – merchants rapidly sprang up in the
immediate area, suddenly placing the old
Franciscan abbey in a lively district with a
distinctly commercial atmosphere. Virgilius
Bononiensis's 1565 city plan clearly shows the
13 weighhouse with the weighing scales outside
and carts laden with merchandise clustered
around it.

One of the four streets beginning at the new
Stadswaag square led to the north transept
of the Franciscan Church. On the west side,
along Mutsaardstraat, the church had a large

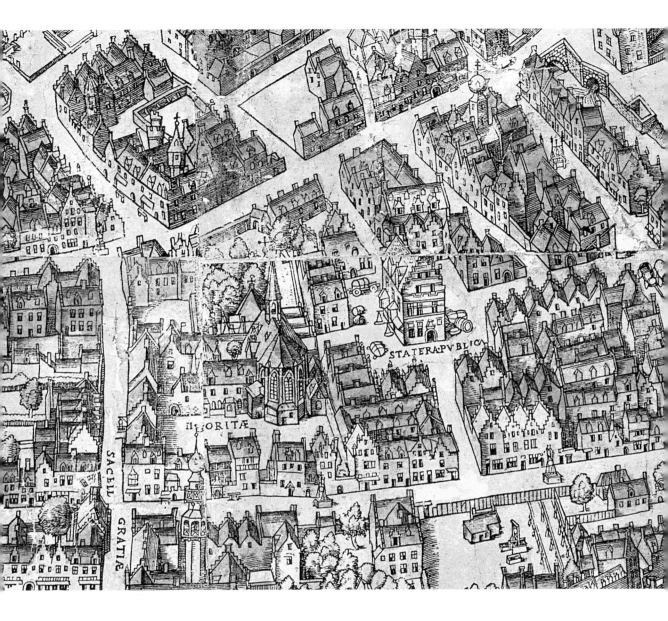

13

Virgilius Bononiensis and Gillis Coppens van Diest
Map of Antwerp, 1565 (detail).
Hand-coloured woodcut.
Museum Plantin-Moretus/Prentenkabinet,
Antwerp, inv. MPM.V.VI.01.002

The Convent of the Friars Minor Recollects and the
city weighhouse (*Statera publica*) seen from the east.
Notice the weighing scales hanging on the exterior
of the weighhouse.

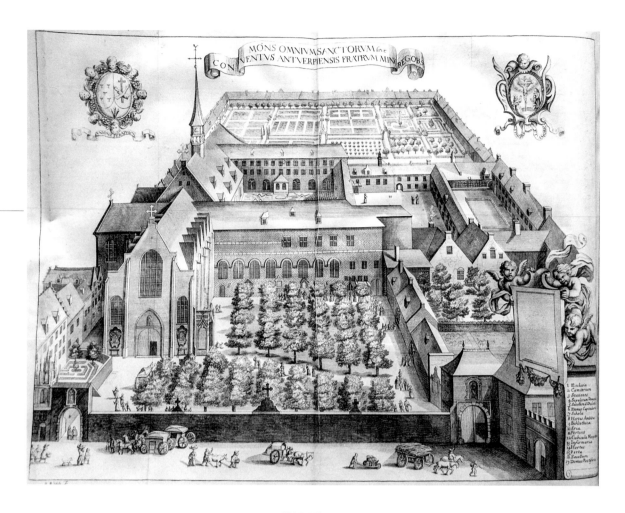

14

Jacob Neeffs, after Philip Fruytiers
*Mons omnium sanctorum sive conventus
Antverpiensis Fratrum Mino[rum] …*, 1666.
Engraving, 337 × 457 mm.
FelixArchief, Antwerp, inv. 12 5314

The Friars Minor Convent from the west.

15

Joseph-Nicolas Mengin?
Plan of the 'Musée d'Herbouville', 1805 (detail).
FelixArchief, Antwerp, inv. 12 5241

During the French occupation the 'Italian School' of
the museum was accommodated in the former choir of
the abolished Friars Minor Church, while the coins and
medals collection was to be found in the Lady Chapel
or 'Rockox Chapel'. The museum was named after the
prefect of the Département des Deux-Nèthes, Charles
Joseph Fortuné d'Herbouville (1756–1829).

16

Anonymous
Plan of the Friars Minor Church with indication
of its objects of interest, late 17th century?
FelixArchief, Antwerp, inv. KK 560

14 parvis on which trees grew, and which might also have served as a cemetery. One entrance was located on Minderbroedersstraat, where the main entrance now stands of the Fine Arts Academy, housed in what remains of the abbey buildings. The 'Berg van Barmhartigheid' (Mount of Mercy, Mount of Charity) was established on the eastern side of the abbey, in Venusstraat, in 1620. It was an officially sponsored pawnshop where poor people could get cheap loans secured by pledging valuables, and was located in the converted English warehouse. From 1956 the building was home to the Antwerp city archives, until their relocation to the Felixpakhuis in 2006.

History

Construction of the abbey began in 1450 on Raamveld, the current location of the Academy. The site on the Kauwenberg that was chosen initially turned out to be unsuitable. In keeping with the wishes of the Duke of Burgundy, the community was dedicated to Sts Andrew and Francis, and the abbey developed into an important Franciscan institution, where no fewer than forty provincial chapter meetings would be held and to which a house for novices was also attached.

The institution was expropriated in 1796 during the French revolutionary occupation, and its goods were publicly auctioned a year later. The empty buildings were used in the French period as a workhouse and as the home of the Fine Arts Academy and its 15 museum, the precursor of today's Koninklijk Museum voor Schone Kunsten. The French architect Joseph-Nicolas Mengin began work on the conversion of the abbey church in 1807. It reopened as the academy museum in 1811. The nave of the church was demolished in 1841 so that the museum could be given a wider wing. The walls of the choir were

incorporated in the new building. When the present Fine Arts Museum was inaugurated in 1890, the Academy took over the buildings.

Building

The lost abbey church was an imposing 16 building measuring almost a hundred metres in length. It was a so-called pseudo-basilica, a three-aisle church whose nave and aisles were covered by a single roof. The nave had eight bays, the choir seven and a polygonal east end. There was a modest bell tower with a needle spire above the roof of the choir. The nave and choir were separated by a rood screen one bay wide. A first chapel was consecrated in 1451, but the building of the church as a whole was not completed before 1500. Two large chapels were built on the north and south side, forming a kind of transept in the mid-seventeenth century. The simple, austere facade with the central entrance survived until 1675, when it was renewed at the expense of a benefactor called Maria Simons and provided with three statues representing Sts Francis and Anthony and the Holy Virgin. By the end of the eighteenth century, the choir was surrounded by a series of other chapels. The abbey buildings adjoined the church level with the choir and there was a large, walled garden to the east of the church and abbey.

THE INTERIOR

The Church of the Friars Minor Recollects became a veritable shrine to art in the two centuries that followed the destruction inflicted during the religious troubles of the sixteenth century. Of the four churches explored in this book, this one will probably have struck visitors as the most lavishly decorated. Sadly, no visual source has survived to show us its extravagant interior.

The height of the nave and the many windows must have created a sense of great space. Stephanus Schoutens (1842–1918), the Franciscan chronicler of his order's monastery in Antwerp, reported that in his time the aisles were panelled in wood all the way around, with a total of no fewer than twelve integrated confessionals – six on either side, matching the number of windows. It seems to have been a larger ensemble, therefore, than that in the nave of the Dominican Church, which boasts ten confessionals (c. 1659). According to the art collector Charles Van Herck (1884–1955), one of the six surviving confessionals that were bought by the Church of Onze-Lieve-Vrouw-ten-Poel in Tienen at the public auction of the contents of the church during the French period bore the date 1671. In their current form, adapted to fit their new location at the beginning of the nineteenth century, they belong to the cell type, in which the spaces for the priest and for the penitents are open at the top. The central space reserved for the pastor is flanked by carved full-length angel figures, whose attributes identify them as personifications of themes relating to penitence. The two

18

17

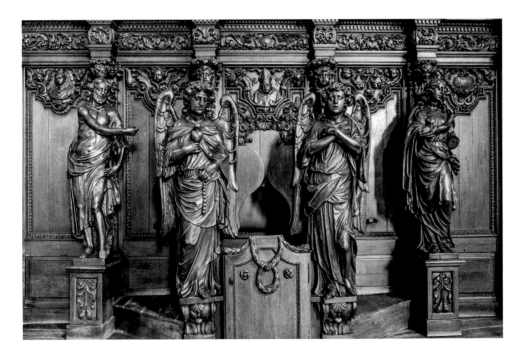

17

One of the confessionals from the Antwerp Friars Minor Church (c. 1671), now in Onze-Lieve-Vrouw-ten-Poelkerk, Tienen

18

Joris Snaet
Reconstruction drawing of the Friars Minor Recollects
Church in the 18th century, 2013

A Van Dyck, *Lamentation* (fig. 24)
B Rood screen
C Rubens, *Last Communion of St Francis* (fig. 30)
D Choir stalls
E High altar with monumental reredos and Rubens's
 Coup de Lance (fig. 43)
F Lady Chapel ('Rockox Chapel')
G Rubens, *Rockox Triptych* (fig. 40)
H Ambrosius Benson, *Deipara Virgo* (fig. 41)
J Chapel of St Peter of Alcantara
K Choir
L St Bonaventura Chapel
M Portiuncula Chapel
N Transept

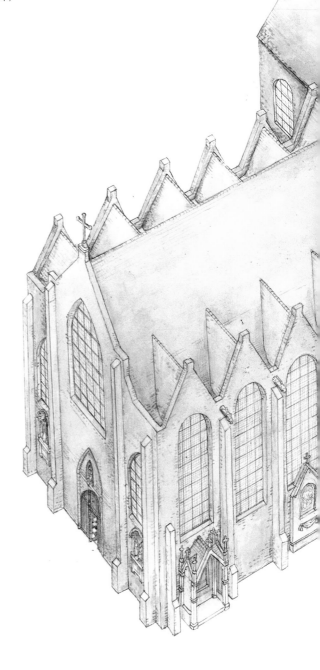

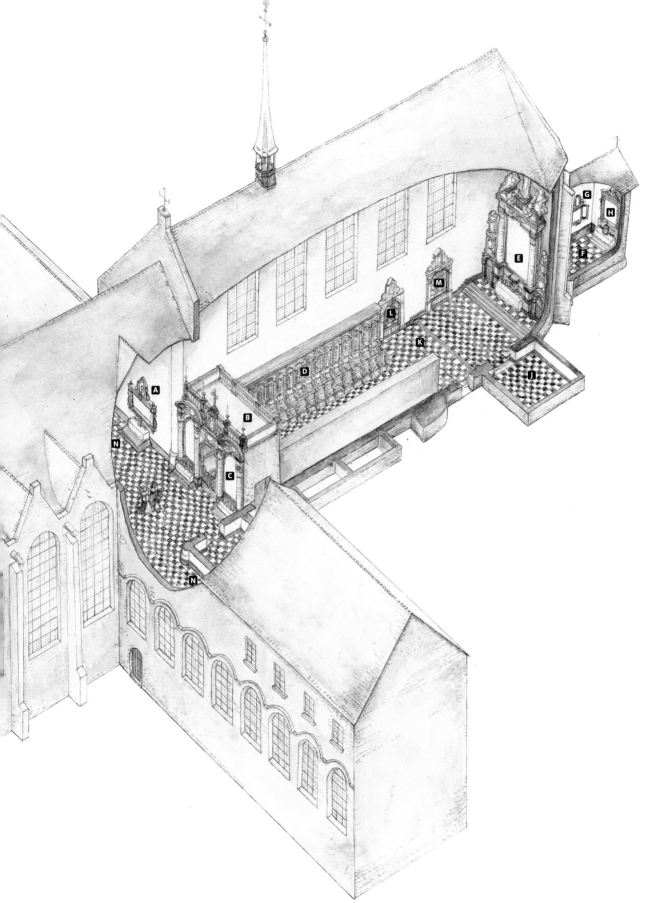

19

Pieter van Lint
The Miracle of St John of Capistrano.
Canvas, 252.4 × 171 cm.
Koninklijk Museum voor Schone
Kunsten, Antwerp, inv. 434

20

Philip Fruytiers
St Louis as Crusader.
Canvas, 254.4 × 167.4 cm.
Koninklijk Museum voor Schone
Kunsten, Antwerp, inv. 166

21

Cornelis Schut
*Portiuncula (St Francis Receiving
the Portiuncula Indulgence from
Christ through the Intercession of
the Virgin Mary).*
Canvas, 337.5 × 244.5 cm.
Koninklijk Museum voor Schone
Kunsten, Antwerp, inv. 326

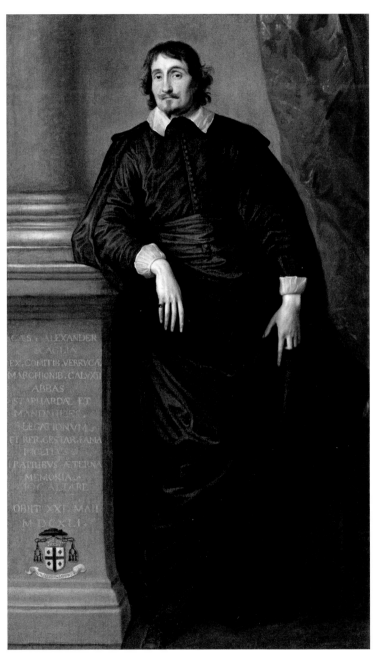

22

Anthony van Dyck
Cesare Alessandro Scaglia di Verrua,
Abbot of Staffarda and Mandanici, 1634–35
Canvas, 189 × 110 cm.
Koninklijk Museum voor Schone Kunsten,
Antwerp, inv. 405

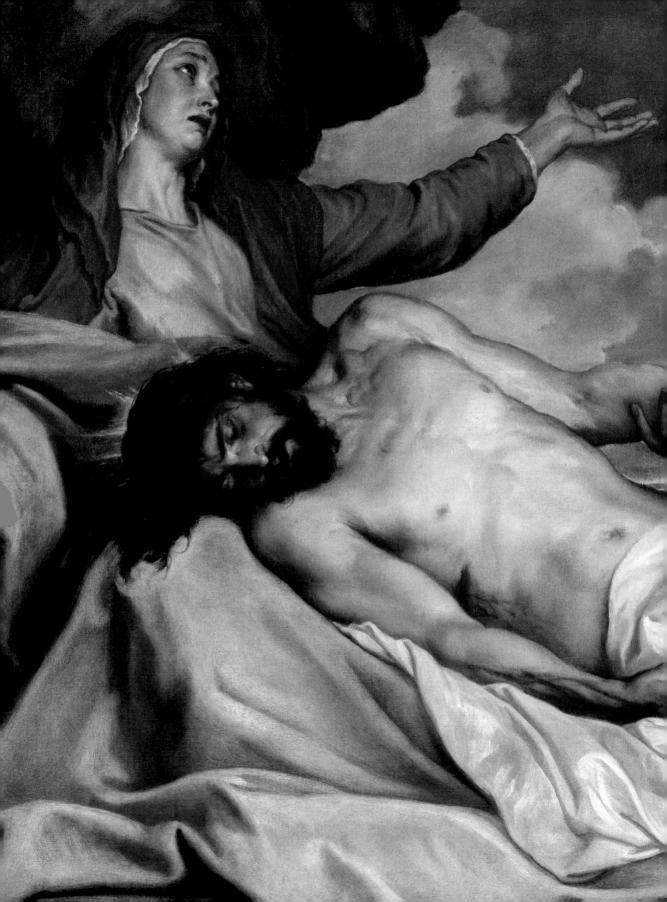

outer sides of the confessional are decorated by two additional sculptures representing either a role model for the penitent such as St Peter or King David, or a saint, mostly of the Franciscan Order, but also of orders like the Premonstratensians and Dominicans. We can, for instance, identify not only Sts Francis, Anthony and Clare, but also Norbert of Xanten and Rose of Lima.

The pulpit stood on the north side of the nave, between the fourth and fifth column from the west entrance. Its body was supported by an image of the order's founder, St Francis of Assisi, with two angels. According to Stephanus Schoutens, it was made by the Antwerp sculptor Mattheus van Beveren (1630–1690), and was presented by the same Maria Simons who had endowed the church with its new facade in 1675. Other sources identify Ludovicus Willemssens (1630–1702) as the pulpit's maker. That Willemssens was 18 B, D responsible for the choir stalls and the rood screen is more widely agreed. Schoutens states that he did the work in collaboration with Artus Quellinus the Younger (1625–1700). The choir stalls were decorated with images of Franciscan saints, interspersed with representations of cardinal and spiritual virtues. According to Schoutens, both features were created between 1682 and 1684. There was an unusual sculpture above the entrance to the choir showing Time seated on a tomb and pointing to the time of day, symbolizing transience.

A series of five paintings depicting important figures in the Franciscan Order hung between the windows of the north aisle. They depicted the order's key female saint, Clare of Assisi, but also Sts Louis of France;

23

Anthony van Dyck
Lamentation over the Dead Christ, 1635
(detail of fig. 24).
Koninklijk Museum voor Schone Kunsten,
Antwerp, inv. 404

Elizabeth, Queen of Portugal; James of the Marches; and John of Capistrano. Two of these works are among the large number of paintings from this church that ended up in the Koninklijk Museum.

Still on the north side, a couple named Lopez Franco y Feo had a large chapel added to the nave in 1649, creating a kind of north transept. The structure replaced a smaller, older chapel founded in 1600 by Diego Pardo and Anna Bejar. Francisco Lopez Franco y Feo was a wealthy Portuguese banker who became owner in 1651 of the castle and seigniory of Kontich near Antwerp. He remained childless, and invested a considerable amount of his wealth in religious foundations. He had already endowed the Chapel of Our Lady of the Visitation at St James's Church, where several members of the Franco y Feo family were buried. Cornelis Schut (1597–1655) painted the colourful altarpiece, which showed in his typically expressive, Italianate style, the presentation of the Portiuncula indulgence to St Francis. Although Schut collaborated

with Rubens on the decorations for the Joyous Entry of Cardinal Infante Ferdinand (1635), his style has little in common with the master. The canvas was set in a costly portico made of white and black marble, on either side of which were presented the kneeling donors, likewise carved in white marble.

This was not, however, the only impressive work of art on the north side of the church: the altar of Our Lady of the Seven Sorrows stood near the east side of the transept, and featured a painted altarpiece by Anthony van Dyck (1599–1641) with the *Lamentation of Christ*. Van Dyck broke with customary altarpiece standards by presenting the scene in a horizontal format. Christ's dead body is stretched out in the lap of the Virgin Mary, who sits on the ground to the left, leaning against a rock and looking beseechingly to the heavens, her arms outspread in despair. St John is shown opposite her, holding Christ's hand and accompanied by two angels. The painting was quickly deemed to be one of the artist's finest works. Its unusual, horizontal

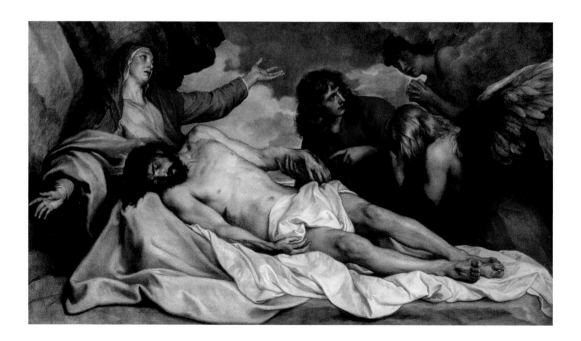

format might reflect the fact that the retable also incorporated three sculptures: the devotional statue of Our Lady of the Seven Sorrows, which probably stood on top of the marble portico, and two other sculptures showing Mary and Joseph's flight into Egypt, which were placed on either side and slightly lower down.

This extraordinary work, now included on the Flemish list of protected master-pieces, belongs today to the collection of the Koninklijk Museum. It was donated by the highly distinguished Cesare Alessandro Scaglia (1592–1641), Count of Verrua and

25

Maarten de Vos
Sts Francis of Assisi and Didacus of Alcalá surrounded by Scenes from the Life of Didacus ('Vita Altarpiece of Didacus of Alcalá').
Panel, 270 × 233 cm.
Koninklijk Museum voor Schone Kunsten, Antwerp, inv. 89–100

◀ 24

Anthony van Dyck
Lamentation over the Dead Christ, 1635.
Canvas, 115 x 208 cm.
Koninklijk Museum voor Schone Kunsten, Antwerp, inv. 404

Van Dyck's *Lamentation* hung in the north arm of the transept (see fig. 18A).

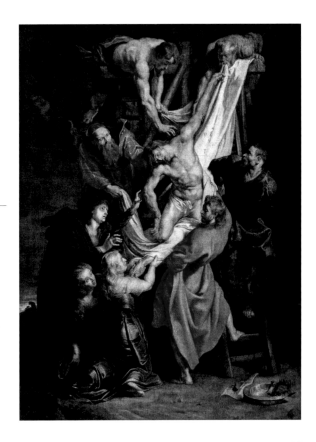

26

Peter Paul Rubens
The Descent from the Cross.
Canvas, 123.3 × 90.2 cm.
Koninklijk Museum voor Schone Kunsten,
Antwerp, inv. 315

This copy of Rubens's *Descent from the Cross*
in Antwerp Cathedral and Pieter Thijs's
painting (opposite) hung in the
'Portiuncula Chapel' (fig. 18M).

a member of the celebrated family from Piedmont. As a diplomat employed by the House of Savoy, Scaglia played a prominent role on the European political stage. He spent time as governor to the dukes of Savoy in Rome, Paris and London, and also worked for Philip IV of Spain. He pursued a religious career too, becoming abbot of Santa Maria di Staffarda, San Giusto di Susa, San Pietro di Muleggio (Vercelli), all located in Piedmont, and of Mandanici in Sicily. For all his ambitions, however, he never achieved the rank of cardinal. An art-lover and admirer of Van Dyck's work, he bought a house in nearby Keizerstraat in Antwerp in 1637, near the end of his life, and became a Franciscan Tertiary at the same time. He bequeathed money for a retable to decorate the altar of Our Lady of the Seven Sorrows after his death, and to fund the *Lamentation* as well. Alessandro Scaglia was buried in front of the altar he endowed.

Under the terms of the same will, the Franciscan abbey came into possession of a monumental portrait of Scaglia that Van Dyck might have painted in 1634 during his stay in the Low Countries. The friars probably sold the original, now in the National Gallery, London, relatively quickly, replacing it with a replica. It is the latter work – which, unlike the original, bears an inscription concerning the donation – that later also found its way into the museum collection. Although this full-length likeness was located above the doorway of a room on the north side of the choir at the end of the eighteenth century, it initially hung next to the altar, where it was seen by, among others, the French painter, art dealer and writer Jean-Baptiste Descamps (1715–1791) before 1769.

The sacrament altar of the Friars Minor Church was located in the south transept, opposite the Lopez Franco y Feo family's altar. The Sacrament Chapel was also known as that of St Didacus, who was commemorated by the painting that hung on its eastern wall in

the eighteenth century: the *Vita Altarpiece of*
25 *St Didacus of Alcalá*. This extraordinary work
by Maarten de Vos, now in the Koninklijk
Museum collection, combines a central scene
with the saint accompanied by Francis, the
order's founder, and surrounded by smaller
scenes from his life.

The altarpiece, however, had no thematic
connection with the Sacrament Chapel's
function, showing as it did the *Coronation*
32 *of the Virgin* by the Trinity. This painting,
attributed to Rubens, now belongs to the

27

Pieter Thijs
*Portiuncula (St Francis Receiving
the Portiuncula Indulgence from
Christ through the Intercession
of the Virgin Mary).*
Canvas, 249.9 × 263.5 cm.
Koninklijk Museum voor Schone
Kunsten, Antwerp, inv. 352

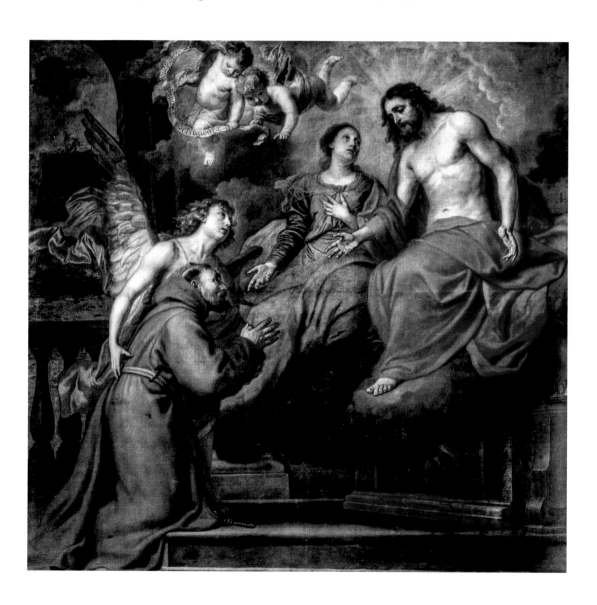

Musées royaux des Beaux-Arts de Belgique in Brussels. Continuing from this transept was another chapel, this one devoted to the Fraternity of the Cord of St Francis, which featured an altarpiece by Philip Fruytiers (1610–1666), now lost, illustrating the cult practised there. A further small chapel, this time devoted to St Apollonia, was located in the corner between the choir and the south transept. These were all the altars that were accessible from the public part of the church, the nave.

According to eighteenth-century accounts, however, the Franciscan Church also had several chapels situated around the choir of the church which therefore were de facto more private in character. There were two such spaces on the north side, the westernmost one containing an altar devoted to St Bonaventura, and the easternmost space dedicated to the Virgin Mary. The Bonaventura Chapel was founded by one Gregorio de Ayala, possibly the famous merchant and banker of Charles V, and was restored in 1587 after the destruction wrought during the Iconoclastic Fury (1566) by the founder's grandson, Gregorius del Plano, superintendent and general dike warden for

28

Anonymous drawing after the portico of the Chapel of St Peter of Alcantara, 18th century? FelixArchief, Antwerp, inv. GF 304, fol. 78

29

Theodoor van Merlen I
The Adoration of the Shepherds.
Engraving.
FelixArchief, Antwerp, inv. 12 8767

Brabant and Flanders. The eastern chapel was referred to in late-eighteenth-century accounts as the Portiuncula Chapel. Its altar was adorned with a painting of the Virgin and Child that has since probably been lost. Several other works also hung in that space, however, which subsequently entered the Koninklijk Museum collection, including

26 a copy after Rubens's *Descent from the Cross*
2 in Antwerp Cathedral; a *Christ on the Cross*, likewise attributed to Rubens; and a work by Pieter Thijs (1624–1677): *St Francis Receiving*
27 *the Portiuncula Indulgence from Christ through the Intercession of the Virgin Mary*. This painting was a memorial to Cornelis de Winter and was installed in 1667.

The Chapel of St Peter of Alcantara stood
18J to the south of the choir, where it was built in 1586 at the expense of Emmanuel Rodriguez d'Évora and his wife Catharina Lopez. The Portuguese couple were *conversos* – converted Sephardic Jews (Évora is about a hundred kilometres to the east of Lisbon). Having settled in Antwerp, Emmanuel went on to found a family branch that rapidly acquired considerable influence, chiefly through its banking activities. The family traded in sugar, spices and diamonds from Brazil and Portuguese India. The entrance to the chapel
28 had a portico topped with the donor figures kneeling around the Risen Christ. A painting of the *Adoration of the Shepherds* stood on the altar, an engraving of which by Theodoor van
29 Merlen is in the Antwerp municipal archives.

RUBENS'S WORKS FOR THE FRIARS MINOR RECOLLECTS CHURCH

A painting commissioned by the Charles family

The first painting by Rubens that visitors to the Church of the Friars Minor Recollects
30 could admire was the *Last Communion of St Francis* which, from the end of the eighteenth century at the latest, adorned the altar on the right-hand side of the partition
18C with the choir, the rood screen. The painting is unlikely to have immediately caught the attention of worshippers, as there were many dark areas within the composition, and the altarpiece was displayed in a poorly illuminated part of the church. On the other hand, these circumstances must surely have made the principal figure in the scene – the virtually naked and emaciated founder of the Franciscan Order – even more powerfully affecting. The work's sober and dark colours are in sharp contrast with the other altarpieces Rubens created in the same period, such as the high altarpieces for the Antwerp Dominicans (*The Vision of St Dominic*, c. 1618–19; Musée des Beaux-Arts, Lyon), the Jesuit Church (*The Miracles of St Francis Xaver* and *The Miracles of St Ignatius of Loyola*, c. 1617–18; Kunsthistorisches Museum, Vienna) and St John's Church in Mechelen (*Adoration of the Magi*, 1616–17), and the altarpieces for the Mechelen fishmongers (*Triptych of the Miraculous Draught of Fishes*, 1618–19; Onze-Lieve-Vrouw over de Dijle, Mechelen) and the tailors' guild in Lier (*Triptych of St Francis*, 1618, centre panel: Musée des Beaux-Arts, Dijon). There can be little doubt that this formal choice was prompted by the decorum of the sorrowful theme depicted.

The Charles family vault was situated in front of the altar of St Francis and their arms featured in the cornice of the altarpiece. The Charleses were prominent merchants,

active in the carpet trade, among others, and were intimately connected with the abbey, which received endowments from several of its members. Petrus Charles – son of Gaspar – became a friar there and Anna Charles, possibly Gaspar's daughter, was buried in the choir of the church following her death on 27 October 1661. An annual commemorative mass was held for her. It was also a certain Gaspar Charles who signed a receipt to the value of 750 florins on 17 May 1619 in respect of 'full and complete payment' to Rubens for a painting destined for the Franciscan Church. The death of a man with the same name was recorded on 6 June 1618, roughly a year earlier, suggesting that the receipt was signed by his son and namesake, who commissioned the altarpiece from Rubens as a memorial to his late father. Gaspar Senior held a number of posts, including those of district warden and almoner. The latter was an unpaid, honorary function, involving administration of a charity for poor relief. The chosen individuals had to be wealthy burghers, as they were frequently required to dip into their own pockets to support the needy.

The keenly affecting altarpiece shows the final moments in the life of St Francis. The founder of the Franciscan Order is shown kneeling before the altar in the Portiuncula Chapel, surrounded by his fellow friars. A priest holds out the Holy Sacrament and a paten. In his desire to follow Christ's example, Francis has removed his habit and cord to appear before God clad only in a loincloth, with his stigmata clearly visible. He covers the wound in his side with his left hand. Several angels have flown in through the open window, their gestures implying that they have come to receive the dying man's soul.

This moving scene has been described since the eighteenth century as the 'Last Communion or Viaticum of St Francis'. Oddly, however, the theme does not occur in the original account of the saint's life or in the iconographic tradition that grew up around him. This is, in other words, a remarkable and highly innovative painting. So what prompted it? As the Franciscan friar Dr John Knipping put it, the depiction of the Holy Communion was very much a hot topic at the time. The sacrament of the Eucharist featured prominently in the religious controversies of the age, and so it took centre stage in the imagery of the Counter-Reformation, which was eager to offer educational illustrations of key points of doctrine. The various religious orders each sought wherever possible to promote their founders and patron saints as ambassadors of those dogmas.

Despite the fact that the administering of the *viaticum* is not mentioned explicitly in the authentic *vitae* of St Francis, these lives and their translations did include elements on which to hang a 'Eucharistic' interpretation of the saint's final moments. There is a passage, for instance, on the celebration of the Holy Sacrament with his fellow friars at the saint's request on the eve of his death. There is also a variation on the Dutch translation of the psalm he sang as he died, which illustrates his *transitus* from earthly to divine heavenly existence. It is precisely this notion of transition, incidentally, that is central to the story of the saint's death rather than that of the *viaticum*.

The closing lines of the psalm are 'Educ de custodia animam meam ad confitendum nomini tuo me expectant iusti donec retribuas mihi'. Contemporary Dutch translations of this psalm no longer rendered *iusti* as *rechtvaardigen* (the righteous), but as *gerechten*, which could also refer in the language of the time to the 'last rites' or sacraments.

Since Rubens could not take his cue from an existing visual tradition or from literary sources, he was obliged to seek other sources of inspiration for his representation

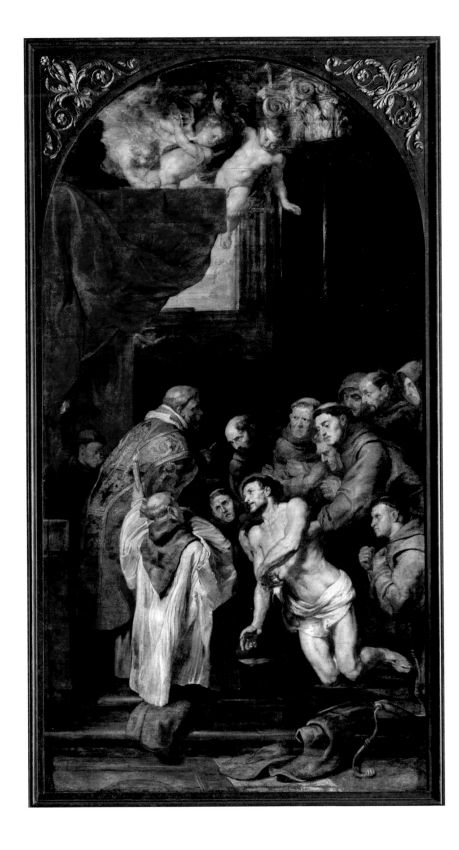

30

Peter Paul Rubens
*The Last Communion of St Francis
of Assisi*, 1619.
Panel, 422 × 266 cm.
Koninklijk Museum voor Schone
Kunsten, Antwerp, inv. 305

31

Philip Fruytiers
Apotheosis of St Anthony of Padua, 1652.
Canvas, 423.5 × 223 cm.
Koninklijk Museum voor Schone Kunsten
Antwerp, inv. 167

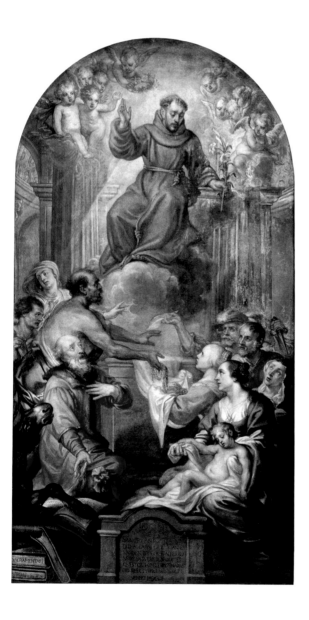

of St Francis's final moments. Two Italian examples of the *Communion of St Jerome* may be cited in this respect: Agostino Carracci's version in Bologna (1589) and Domenichino's in St Peter's in Rome (1614), the similarities with which are remarkable.

Some authors have noted the highly realistic character of the depicted friars, suggesting that the painting might have been linked to the celebration of the *transitus* rite by the members of the fraternities devoted to St Francis. There was a tradition among these groups to assemble on the eve of the anniversary of the saint's death to celebrate the Eucharist in the manner Francis requested in the *vitae*. The brown candle carried by one of the acolytes in the altarpiece functioned in this rite as a symbol of the order's founder, whose life was about to be extinguished. There was a fraternity at the Franciscan Church in Antwerp devoted to the Cord of St Francis, which may have been founded in 1591–92. The prominent presence of the cord in the foreground of the painting suggests a possible connection with that sodality.

It is highly unlikely, however, that these are portraits of members of the fraternity or of the monastic community, as the ecclesiastical authorities had banned portraits of living people in altarpieces in 1607. It had not been unusual, prior to that, for donors to have themselves included in the religious scenes they commissioned. In the light of Catholic reform, however, this was deemed no longer appropriate: there was no place for lay people in a holy image. With a few rare exceptions, these instructions were dutifully followed.

From the late eighteenth century onwards, the altarpiece was invariably mentioned as adorning the south rood screen altar. Since the patrons of the altarpiece, the Charles family, also had their vault at that spot, this was probably the painting's original location.

The frame – and hence possibly also the rood screen format – of the painting was, however, altered on several occasions. There is evidence, for instance, that it was trimmed on both sides and extended at the bottom. The painting was given a new frame in the second half of the eighteenth century, made by Ludovicus Willemssens, the sculptor who also provided the abbey church with a new rood screen and choir stalls. The altar was re-dedicated in 1675, and so the changes probably date from around that period. By 1706, the state of the frame was found to be so bad that urgent restoration was needed. This was funded by the same generous benefactor, Maria Simons, who had paid for the new facade, pulpit and choir stalls.

It cannot be ruled out that the painting was initially located somewhere else and that the Charles family's mausoleum was also altered over time. Re-interment elsewhere in the church did sometimes happen, as we will see below. The possibility should be taken into account because the altarpiece of the corresponding north altar, dedicated to St Anthony of Padua, is considerably more recent than Rubens's work: it was not until 1652 that Philip Fruytiers painted

31 his *Apotheosis of St Anthony of Padua*. It is quite conceivable that at that moment the *Last Communion of St Francis* was moved from its (unknown) earlier location to join Fruytiers's picture on the rood screen.

On the other hand, reference should also be made in this regard to the similar, rounded shape of the altarpiece with the

32 *Coronation of the Virgin* in the Musées royaux des Beaux-Arts de Belgique, which David Freedberg believes to have been painted around 1620. The two works are also comparable in height. The panel of the *Last Communion*, however, which is supposed to have been narrowed on either

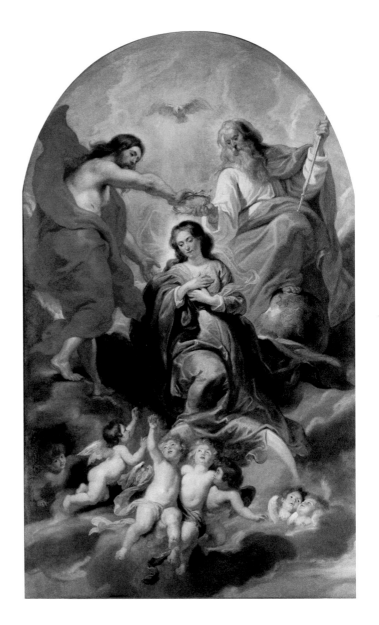

32

Peter Paul Rubens
The Coronation of the Virgin, 1620?
Canvas, 415 × 257 cm.
Musées royaux des Beaux-Arts de Belgique/
Koninklijke Musea voor Schone Kunsten
van België, Brussels, inv. 162

side, is a little less wide. It is therefore also possible that the two Rubens paintings were initially companion pieces and that the *Coronation* was not moved from the rood screen to the south transept – where it replaced Fruytiers's picture – until after 1652.

Paintings commissioned by the Rockoxes

The most famous of Rubens's paintings for the Franciscan Church did not hang in the public part, however, but in the section reserved for the friars. They were the 43, 18 E celebrated *Coup de Lance*, which decorated the high altar, and a memorial triptych with 40, 42, 18 G the *Incredulity of St Thomas* and portraits of the donors, which was done for the Lady Chapel, dedicated to the Immaculate Conception, to the rear of the high altar. Both works were part of what might be called a commemorative scheme intended to promote the salvation and memory of 40 Chevalier Nicolaas Rockox (1560–1640),

alderman and burgomaster of the city of Antwerp, and his wife Adriana Perez, daughter of a Spanish merchant. Rockox may also have 2 been the donor of a *Christ on the Cross*, an 34 hypothesis based on the initials 'NR' placed on the wood of the cross beneath Christ's feet. 26 Together with a reduced copy of the *Descent from the Cross* in the cathedral (123 × 90 cm), it was one of a pair of small-scale works by the master which, like his monumental paintings, were present in the church and later found their way into the museum.

Nicolaas Rockox played a decisive role in the flying start to Rubens's career in Antwerp following the painter's return from Italy on his mother's death in 1608. The fact that Rubens's much-loved brother Philip belonged to the same intellectual and social network will no doubt have helped in that regard, and Rockox was also godfather to Philip's son, Philip Rubens Jr. Rockox personally commissioned a painting of *Samson and Delilah* from Rubens in around 1609, which became a show-piece in his home (now National Gallery, London).

He was burgomaster in the period that the civic authorities ordered an *Adoration of the Magi* from Rubens for the States Chamber in the City Hall, where the Twelve Years' Truce (1609–21) was negotiated. And Rockox was likewise dean of the Guild of Arquebusiers (*Kolveniers*), which commissioned the celebrated *Descent from the Cross* triptych (1612–14).

34

Peter Paul Rubens
Christ on the Cross (detail of fig. 2).
Koninklijk Museum voor Schone Kunsten,
Antwerp, inv. 313

It is assumed, among other things on the basis of the initials NR on the cross beneath Christ's feet, that Nicolaas Rockox also donated Rubens's *Christ on the Cross* to the Friars Minor Church.

◀ 33

Jan Blom
Plan of the Friars Minor Convent,
late 18th century.
FelixArchief, Antwerp, inv. DWG 5748

Thanks partly to Rockox's patronage and mediation in artistic commissions, the two fine gentlemen became friends, prompting the artist to describe Rockox in a letter to Palamède de Fabri, Sieur de Valavez (3 July 1625) in the following terms: 'He is an honest man and a connoisseur of antiquities. … He is rich and without children, a good administrator and all in all a gentleman of the most blameless reputation.' This friendship did not, however, stand in the way of commercial transactions. In the same year that he most likely received Rockox's commission for the *Coup de Lance*, 1619, Rubens bought a farm, located in Zwijndrecht, from his friend.

The fact that Rockox was wealthy and had no heirs no doubt contributed to the costly nature of his gifts to the Franciscans. Churchgoers granted permission to enter the choir through the door in the rood screen must have felt their stomachs turn as they approached the scene being played out on the high altar. The latter was adorned, as in many churches at the time, with a Crucifixion scene. But this was a very special interpretation of that common theme: neither Christ on the Cross nor the Lamentation over the dead Christ is shown here, but the grisly moment where the soldiers make sure the condemned men are 36 dead. Christ's heart is pierced with a lance, while the legs of the Bad Thief are broken with a baton to hasten his death through suffocation under his own weight. Mary Magdalene tries helplessly to stop the Roman executioner from stabbing Christ's body.

The scene was incorporated in a 35,18 E monumental marble reredos which, in the eighteenth century at least, supported three statues: the *Immaculata* flanked by the kneeling apostles St Andrew and St John. The Virgin Mary is presented as the Woman of the Apocalypse, with the sun and moon as attributes. Andrew was one of the patron

35

J. H. Altenrath
Survey drawing of the high altarpiece
in the Friars Minor Church, 1800–25.
614 × 383 mm.
Museum Plantin-Moretus/Prentenkabinet,
Antwerp, inv. CVH423

Photomontage with Rubens's *Coup de Lance*.
The doorways on either side of the reredos
led to the Lady Chapel ('Rockox Chapel').

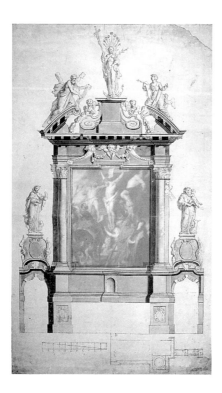

36 ▶

Peter Paul Rubens
Christ on the Cross ('Coup de Lance'),
1620 (detail of fig. 43).
Koninklijk Museum voor Schone
Kunsten, Antwerp, inv. 297

saints of the Franciscan Church, while the
presence of John the Evangelist might be
explained by his (supposed) authorship of
the Book of Revelation.

According to the Antwerp art chronicler
Jacobus van der Sanden (1726–1799), the
figures were carved by Michiel van der
Voort the Elder (1667–1737). We know that
the Madonna statue was endowed by the
priest Johannes Brant in 1715, which means
the figures did not belong to the original
altarpiece decoration. They might have
replaced original sculptures, as Van der
Sanden appears to suggest in a somewhat
vague passage. The design of the portico's
cornice with a plinth in the centre makes it
likely that at least one statue was originally
intended.

There were two small marble doorways on
either side of the reredos in the eighteenth
century, on which marble statues were
placed. These represented the order's key
saints: on the left (the heraldic right, 'Gospel'
side) its founder, St Francis, and on the right
(heraldic left, 'Epistle' side) St Anthony of
Padua. Francis was shown treading on a
globe, symbolizing his contempt for the
material world. The lamb presented to him
by a benefactor stood at his feet. In the
Portiuncula Chapel, the animal worshipped
the Holy Sacrament and knelt before the
altar. St Anthony of Padua was identifiable
from the Christ Child sitting on an open
book and pointing towards an image of
the Redeemer during the saint's nocturnal
vigil. The donkey at his feet referred to the
conversion of the heretic Bombilius, who
did not believe in the true presence of Christ
in the Eucharist. The donkey, however, did
believe and knelt down in the presence
of the Host. Both sculptures were carved
as memorials. St Francis was donated by
the priest Gerard Borrekens and his sister
Susanna Borrekens, St Anthony by Marguerite
Steymans, who died in 1684. Jacobus van der

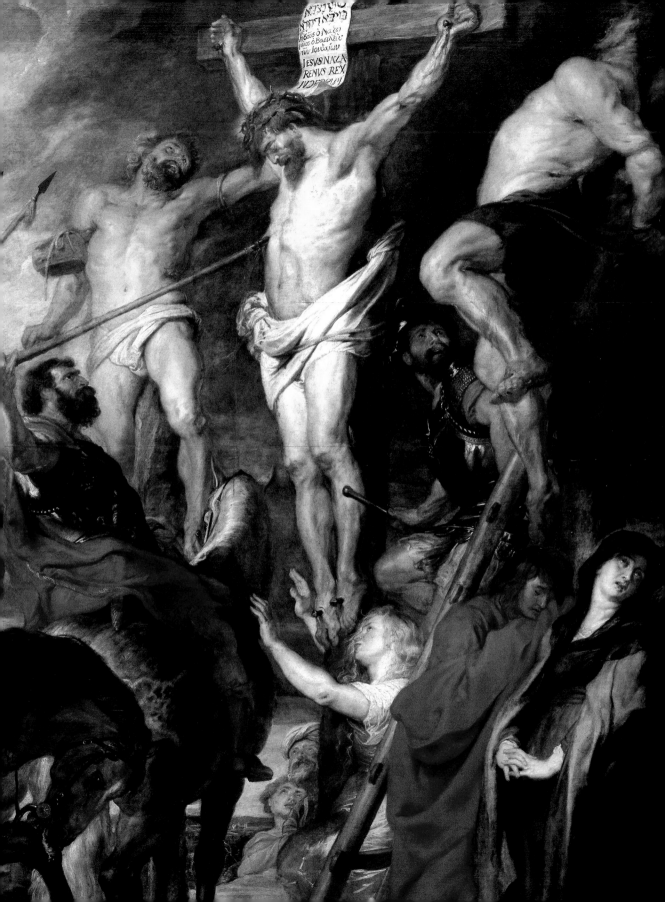

37 | 38

Adriaen Thomasz Key
*Gillis de Smidt with seven of
his children and his second
wife Maria de Deckere with
one of their daughters*, 1575.
Panel, 181 × 118 cm (each).
Koninklijk Museum voor
Schone Kunsten, Antwerp,
inv. 228/229

Interior wings of the
Triptych of Gillis de Smidt
(whose centre panel is
lost), which served as
the high altarpiece of the
Friars Minor Church until
it was replaced in 1620 by
Rubens's *Coup de Lance*.

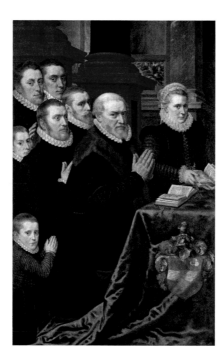
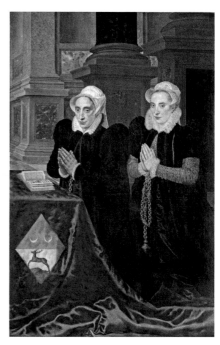

Sanden attributed the sculptures to Artus Quellinus the Younger. Antwerp Cathedral has a very similar wooden image of St Anthony which came from the Franciscan Church and has been attributed to the same artist. It appears, however, to have already been created by 1675. The donkey is missing here, but he can be seen in a very similar terracotta bozzetto from the Van Herck collection (now KMSKA).

According to Adolf Janssen and Charles Van Herck, who based themselves on the scale drawing by J. H. Altenrath, the retable as a whole, including the two doors and the cornice sculptures, measured 9.35 metres across and no less than 14.25 metres in height. Daniel Papebrochius records that the immense ensemble was harmoniously proportioned relative to the height of the choir, and was constructed in different varieties of marble. The customary combination in this period was the two Belgian 'marbles' – red and black limestone, which took on a marbled appearance when polished, with alabaster for the ornamental sculpture and capitals.

The story of the high altar most likely began in the summer of 1619, by which time Rockox's wife Adriana might already have been afflicted with a life-threatening illness. Did she fall victim to the plague? Antwerp had certainly suffered a fresh outbreak of the 'hasty sickness', which flared up regularly in the Southern Netherlands. Whatever the precise cause, Adriana Perez died on 22 September 1619, aged barely fifty-one.

At that moment Nicolaas Rockox had already begun, however, to organize an imposing memorial to his beloved wife. Just over a week earlier, on 14 September 1619, the Antwerp sculptor Melchior van Boven (d. 1620) – a former pupil of the court artist Robrecht de Nole (d. after 9 July 1636) – signed a contract in Namur with the master stonecarver Jean Brigaude. The document related to the supply of the architectural elements of a marble portico, stating explicitly that these were intended 'pour le

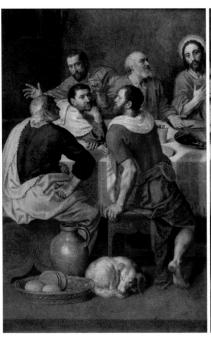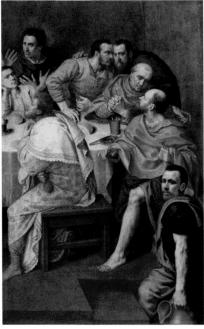

39

Adriaen Thomasz Key
The Last Supper, 1575.
Panel, 181×118 cm (each).
Koninklijk Museum voor
Schone Kunsten, Antwerp,
inv. 230/231

Exterior wings of the
Triptych of Gillis de Smidt,
the original high altarpiece
of the Friars Minor Church.

dressement d'une table d'autel servante pour le grand autel des frères Cordeliers en ladite ville d'Anvers'. It seems likely that Rockox had also approached his friend, Peter Paul Rubens, in the meantime with the request to start work on an altarpiece showing the *Coup de Lance*.

Was Rockox's generosity the only reason behind this renewal? The personality of the then guardian of the abbey, Wilhelmus Spoelbergh (d. 1633), might also have played a part. An erudite clergyman, he was the author of many devotional works and the initiative for the new retable might have resulted in part from his pious influence. There is another possibility too, however, as it is not clear whether the old altarpiece, which Adriaen Thomasz Key (1534/54–1589/1609) painted in 1575, still decorated the high altar in 1619. The painting did remain in the church until its expropriation at the end of the eighteenth century, and 37–39 its wings now belong to the museum collection, although the central panel of

the triptych has been lost. We know that it showed the death of Christ, just like the *Coup de Lance*, but not whether it depicted the same moment in the story.

Not only must that altarpiece have seemed old-fashioned – the triptych format had by now gone out of fashion – there was the added problem that it included portraits. This was because the work had a dual function: on the one hand it was intended to adorn the abbey's high altar, while on the other it was the memorial of the De Smidt-De Deckere family who had donated it. The open wings therefore included portraits of family members, something now prohibited by the ecclesiastical ordinances of 39 1607. The depiction of the *Last Supper* on the closed shutters also appears to have included portraits. The background to Rubens's altarpiece sheds light not only on the possible motives for replacing the existing work, but also on the iconographic continuity and the context of the commission, which should be viewed from a funerary perspective.

The new high altarpiece came into use in the course of the year following the death of Rockox's wife, since when Adriana Perez had been interred in a tomb below the high altar. The altarpiece therefore served as her memorial. Construction began at the same time of a chapel to the east of the chancel. This was accessible to the friars via the two small doorways on either side of the high altar, which led to the rear of the portico behind the altar, where the tabernacle was located. The entrance to the chapel dedicated to Our Lady of the Immaculate Conception was located opposite this sacrarium, in which the wafers were kept.

The position of the chapel – at the head of the church – was liturgically very important. Such chapels were traditionally dedicated to the Virgin Mary and accordingly named 'Lady Chapels'. (It is interesting to note in this regard that Rubens too was buried in a chapel with the same high liturgical status, in St James's Church.) What we know as the 'Rockox Chapel' was thus actually dedicated to the Immaculate Conception, although it might also have served from the outset as the equivalent of the Portiuncula Chapel. The Dutch painter Jacob de Wit (1695–1754), for instance, still referred to it in those terms in the eighteenth century.

It was at the Portiuncula – a chapel near Assisi devoted to Our Lady of the Angels – that St Francis was first called by Christ, and he returned there at the end of his life to die. In view of its immense spiritual importance, the place of worship was granted the privilege of an indulgence. At first, the 'Portiuncula Indulgence' could only be obtained at the chapel in Assisi itself, but Pope Gregory XV considerably extended its scope on 4 July 1622, by also granting the indulgence to any believer who, having received the sacraments of Confession and the Eucharist, visited a Franciscan Church on 2 August, the feast day of Our Lady of the Angels. The construction of the chapel may, therefore, have been linked to this significant extension of the Portiuncula Indulgence. Father Antonius Gonzalez noted in his *Hierusalemsche reyse* ('Journey to Jerusalem', 1678) that the Portiuncula Indulgence brought unprecedentedly large numbers of worshippers to Antwerp, claiming that no fewer than 28,000 people took communion on the date in question. The Portiuncula Chapel was therefore installed in the period 1619–24, perhaps more specifically between 1622 and 1624.

The second work that Rockox commissioned from Rubens, a commemorative painting for his wife and for himself, was meant for this chapel. Rubens had already painted a portrait of Nicolaas Rockox himself some years before working on the *Coup de Lance*, between 1613 and 1615. Those two dates are inscribed in the left panel of the memorial triptych, which includes the donor's likeness. The originally inscribed date, 1613, was probably altered to 1615 sometime later and is generally interpreted as referring to the date of delivery of the complete triptych. If that is the case, the painting is certainly evidence of forward planning on the Rockoxes' part as far as their memory is concerned, as there was nothing at all to suggest at that point that either of them would die. Adriana's unexpectedly early death did not occur until four years later, and Nicolaas survived for no fewer than twenty-five more years.

This was by no means Rubens's first epitaph. The first commissions he received in this regard were all from patrons who were friends of his. He painted his first epitaph, for which he was paid 600 florins, for the publisher Jan Moretus the Elder (1543–1610) and his wife Martina Plantin in 1612. The triptych was destined for the principal church in Antwerp, where it hangs to this day. Jan Moretus was the father of Balthasar Moretus, with whom Rubens attended school and who remained his friend for life. Balthasar wrote a memorial text for Rubens's brother Philip, who

died in August 1611. Jan Moretus published the book *Electorum libri II*, written by Philip Rubens on the subject of classical literature and illustrated by his brother. Probably in the same period as Rubens produced the Rockox epitaph, he painted a memorial for the father of another friend: Jan Brueghel the Elder. The memorial for the latter's father Pieter Bruegel the Elder was intended for the Church of Notre-Dame de la Chapelle in Brussels.

The Rockox memorial picture hung on the left wall of the Portiuncula Chapel, where it was lit by the warm southern light falling through the clerestory windows in the wall opposite. The exquisite painting of the *Deipara Virgo* (Glorification of the Virgin) that adorned the altar was attributed in the Ancien Régime to Quinten Metsys or Hans Holbein, but it was

later discovered that this image of the Virgin and Child with prophets and sibyls is actually a key work in the oeuvre of the Bruges painter Ambrosius Benson (1480/1500–1550).

Unlike his friend Rubens, Rockox did not remarry, despite outliving his wife by just over two decades. He was able to use his chapel throughout that period for private or daily masses, and to attend the annual memorial mass for his wife, which was celebrated at the high altar.

This prompts an intriguing question: how did Nicolaas Rockox, a layman, access his chapel, which could apparently be reached only through the choir – a space reserved in principle for the friars? A possible answer is provided by an archive text, which refers to an *oratorie* above the chapel entrance.

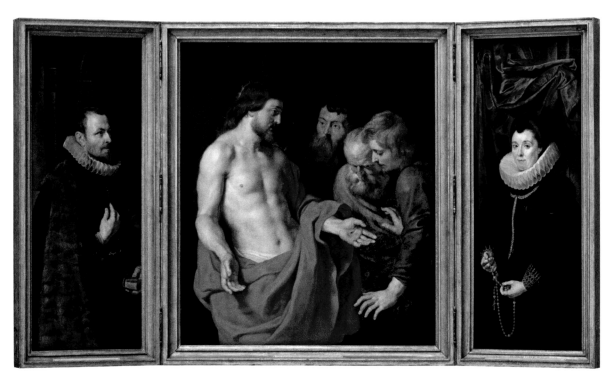

40

Peter Paul Rubens, *Rockox Triptych*, 1613–15. Panel, 146 × 233 cm. Koninklijk Museum voor Schone Kunsten, Antwerp, inv. 307–11

On the wings are the donor portraits of Burgomaster Nicolaas Rockox and of his wife, Adriana Perez, who died in 1619.

Perhaps this was a kind of gallery, accessible via stairs leading from an adjacent space that was connected to the public area. One cannot help being reminded of a famous surviving example of this: the oratory of Louis of Bruges, Lord of Gruuthuse, that looks out on the interior of Our Lady's Church in Bruges (1472).

Nicolaas Rockox himself died on 12 December 1640. He seems to have been aware that the end was near, as he had the notary Cornelis de Brouwer draw up an agreement nine months before his death with the order's provincial superior, Hermanus Lisens. The document set out the arrangements for his funeral, his *commemoria*

and the salvation of his soul, and is also the source of our knowledge that his late wife had been re-interred a few months previously in the vault Rockox had provided for both their remains in the chapel. Having rested for more than twenty years by the high altar, Adriana was to be reunited with her husband.

We do not know whether Rockox had the memorial triptych – which, before the building of the chapel, was located in some other, unidentified spot – hung in his private chapel after his wife's death in 1619, but this is certainly plausible. On the other hand, it is also possible that the triptych was only placed in its final position after his own death. Either way, both of the works that Rockox commissioned from Rubens are closely related in terms of their content. The theme that links them so intensely is that of 'seeing' Christ, a metaphor for true faith.

The centre panel of the memorial triptych shows the Risen Christ, the wound in whose left hand is being studied by a 42 younger figure and an older one. A second older person gazes intently at Jesus from the background. The scene is traditionally identified as the Incredulity of Thomas, an interpretation that dates back to Jacob van der Sanden's description of the work in the eighteenth century. Van der Sanden thought that the young man was the apostle Thomas, and the older figures St Peter and St Paul. Other authors have, however, questioned that reading of the theme, due most notably to differences compared to the way the subject is traditionally presented in art. The most common approach is to show Thomas, gripped by doubt, inserting his finger into the wound in Jesus' side to verify the 'authenticity' of Christ's manifestation. That is not what we see here: indeed, the wound in his side is not even visible. While some scholars have sought to defend the Incredulity theory by arguing that the wound must have been overpainted or else is located

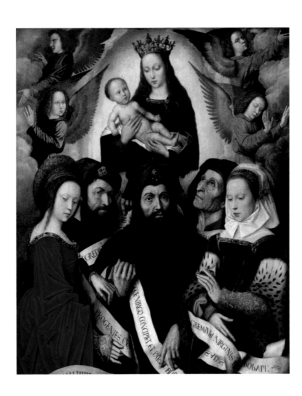

41

Ambrosius Benson
Deipara Virgo, 1530.
Panel, 131 × 108 cm.
Koninklijk Museum voor
Schone Kunsten, Antwerp, inv. 262

Altarpiece of the 'Rockox Chapel' (Lady Chapel).

out of sight on the left side of Christ's body, it seems more likely that the scene shows Jesus' appearance to his disciples in a more general sense.

Christ is said to have appeared several times to the apostles, among others, following his death on the cross. The disbelief shown by Thomas comes from the account of the event in St John's Gospel in which, unlike the version in Luke, Christ appears twice (John 20:20, 24–29; Luke 24:33–43). John describes the first occasion as follows: 'Jesus came and stood among them and said, "Peace be with you." After he said this, he showed them his hands and his side. Then the disciples rejoiced when they saw the Lord.' According to John, Thomas was not present on this first occasion. When they see him, they tell him: 'We have seen the Lord.' But he said to them, 'Unless I see the mark of the nails in his hands, and put my finger in the mark of the nails and my hand in his side, I will not believe.' This, John says, duly happened at the time of the second appearance: 'A week later his disciples were again in the house, and Thomas was with them. Although the doors were shut, Jesus came and stood among them and said, "Peace be with you." Then he said to Thomas, "Put your finger here and see my hands. Reach out your hand and put it in my side. Do not doubt but believe." Thomas answered him, "My Lord and my God!" Jesus said to him: "Have you believed because you have seen me? Blessed are those who have not seen and yet have come to believe."' There is no reference to a second appearance nor to an incredulous apostle in Luke's Gospel.

There are two further arguments, in addition to the differences compared to traditional presentations, that argue against the identification of the theme as the Incredulity of Thomas. The first has to do with internal consistency. The theme of the work, which Adolf Monballieu was the first to identify as *Christum videre* – the seeing

of Christ – is, as we will see in a moment, aligned with that of the high altarpiece. It therefore seems highly unlikely that the donors of the triptych, for whom it was plainly intended as a profession of faith (as witnessed by the book and the paternoster they hold), would have chosen as the central theme of their memorial a subject exemplifying the very opposite. Commemorative paintings with a moralizing theme were not unusual, but an incredulous Thomas simply has no connection with the deceased couple. The faith of the other apostles, by contrast, who testified without the slightest hesitation that they had seen Christ, did have such a connection.

The second argument relates to the way 'Thomas' is depicted: in this respect too, the painting deviates from the traditional approach, in which the apostle is shown as a middle-aged man with a beard, based on the idea that the translation of his name in the apocryphal 'Acts of Thomas' meant 'twin', which was interpreted as meaning that Thomas was Christ's brother and likeness. The young beardless apostle who gazes at Christ's hands more closely resembles the traditional depiction of St John, above all in Rubens's oeuvre.

Then there is the question of why the wound in Christ's side is not visible, for which several explanations can be offered. Perhaps it cannot be seen because Rubens placed the wound on the anatomically accurate but historically unusual left side of Jesus' body (although he did not do this in the *Coup de Lance*). The absence may also be a reference to Luke's Gospel, which does not mention the wound in Christ's side in the context of his reappearance. In my view, it is also possible that the absence of the wound in this instance alludes to the central theme of the painting: 'Blessed are those who have not seen and yet have come to believe' – in other words, you do not necessarily have to see something

43

with your own eyes to believe it. Although the wound was not visible – either to the apostles or to Nicolaas Rockox, Adriana Perez and their descendants – they believed nonetheless that Christ had appeared to his disciples after his death. Rockox and his wife were testifying here to their belief in the Resurrection and life after death. As the Church Father Augustine wrote in his sermon on the Ascension of Christ: 'It is no great thing to see Christ with eyes of the body, but it is a great thing to believe in Christ with the eyes of the heart.'

43 Rubens's magisterial painting for the high altar shows the Crucifixion – a customary theme for an altarpiece with this function in Franciscan churches, including those of the

Peter Paul Rubens
Christ on the Cross
('Coup de Lance'), 1620.
Panel, 429 × 311 cm.
Koninklijk Museum voor Schone Kunsten, Antwerp, inv. 297

The high altarpiece of the Friars Minor Church (from 1620) was also donated by Nicolaas Rockox.

◀ 42

Peter Paul Rubens
Rockox Triptych. Centre panel: *'The Incredulity of Thomas'*, 1613–15 (detail of fig. 40).
Koninklijk Museum voor Schone Kunsten, Antwerp, inv. 307–11

The subject is traditionally identified as the 'Incredulity of Thomas', but as the crucial wound in Christ's side is invisible or even missing, it seems more likely that the scene shows Christ appearing to his disciples in a more general sense.

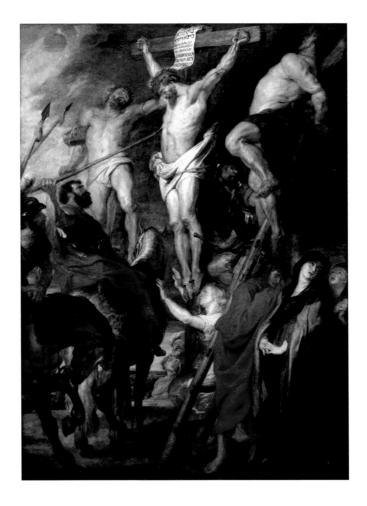

abbeys in Ath, Lille, Mechelen and Bruges. It was a reflection of Franciscan spirituality which, following the founder's example, focused strongly on the Passion of Christ. The theme was, moreover, a common one with which to adorn seventeenth-century altars, especially high and sacrament altars.

The strikingly epic and cruel character of the Antwerp version is, however, a departure from customary representations of the Crucifixion in this period. It is plainly inspired by the most detailed account of the Passion, namely the one provided in John's Gospel, more specifically the events described after Christ's actual death: the lance-thrust and the *crurifragium* or breaking of legs (19:31–36). The motif of the *Stabat Mater* – the Virgin Mary standing at the foot of his cross mourning over her dead son – also derives from that source and was extremely popular in Franciscan circles.

It may not be immediately obvious, but seeing as a metaphor for true faith is also a central theme of Rubens's altarpiece, which shows the moment of the lance-thrust, in which the Roman soldier Longinus pierces Christ's heart with his lance. According to tradition, a drop of blood from the wound in Jesus' side splashed into Longinus's blind eye, miraculously curing it, and prompting his immediate conversion to Christianity.

The depiction of the bodily fluids – water and blood – flowing from Christ's side is indebted to the visual tradition of the *fons vitae*, the fountain of life. St Bonaventure, the Franciscan theologian, Doctor of the Church and biographer of St Francis, wrote: 'He is the Tree of Life for by this means we return to the very fountain of life and are revived by it.' The Tree of Life – *lignum vitae* – is a Franciscan theme *par excellence* and it is possible that the depiction of the vertical member of the cross as a tree-trunk is a reference to that image. Bonaventure actually devoted a whole book, *The Mystical Vine*, to the theme, which derives once again from John's Gospel (15:1–17). A chapter on the vanquishing of death includes a passage dealing with the lance-thrust or *Iesus translanceatus*, describing the blood and water flowing from Christ's side as sources of eternal life.

This faith in Christ as the source of salvation and eternal life, expressed in the believer's 'seeing' of the source, links remarkably well with the verse that immediately follows the account of the lance-thrust in John's Gospel: 'He who saw this has testified so that you also may believe. His testimony is true and he knows that he tells the truth' (19:35). The Perez family motto, adopted by Nicolaas Rockox, expresses the same idea: *In Christo Vita*.

SOURCES

Antwerp, FelixArchief, PK 171–173,
J. van der Sanden, Oud Konst-Toneel van
Antwerpen.

Antwerpen, FelixArchief, GF 304.

Leuven, Kadoc, Archief minderbroeders,
no. 154, Convent. Antverpiensis.

LITERATURE

S. Barnes, N. de Poorter, O. Millar et al.,
*Van Dyck: A Complete Catalogue of the
Paintings*, New Haven 2004.

Frans Baudouin, *Nicolaas Rockox, 'vriendt ende
patroon' van Peter Paul Rubens*, Antwerp 1977.

M. Casteels, *De beeldhouwers de Nole
te Kamerijk, te Utrecht en te Antwerpen*
(Verhandelingen van de Koninklijke Academie
voor Wetenschappen, Letteren en Schone
Kunsten van België. Klasse der Schone
Kunsten, 16), Brussels 1961.

T. Coomans, 'L'architecture médiévale des
ordres mendiants (franciscains, dominicains,
carmes et augustins) en Belgique et aux Pays-
Bas', *Revue belge d'archéologie et d'histoire de
l'art* 70 (2001).

C. Cryns and M. Gys, 'Bouwgeschiedenis van
de Academie van Antwerpen 1811–1900',
unpublished thesis Hogeschool Antwerpen,
1996.

L. de Jong et al., *Het Koninklijk Museum voor
Schone Kunsten Antwerpen: een geschiedenis,
1810-2007*, Oostkamp 2008.

J.-B. Descamps, *Voyage pittoresque de la
Flandre et du Brabant: avec des réflexions
relativement aux arts & quelques gravures*,
Paris 1769.

J. de Wit, *De kerken van Antwerpen. Schilderijen,
beeldhouwwerken, geschilderde glasramen,
enz., in de XVIIIe eeuw beschreven door Jacobus
De Wit* (ed. J. de Bosschere) (Uitgaven der
Antwerpsche Bibliophilen, 25), Antwerp and
The Hague 1910 [1748].

D. Freedberg, *Rubens, The Life of Christ after
the Passion* (Corpus Rubenianum Ludwig
Burchard, VII), Brussels 1984.

[P. Genard], *Verzameling der graf- en
gedenkschriften van de provincie Antwerpen,
Antwerpen: kloosters der Orde van St-Franciscus*,
Antwerp 1871.

V. Herremans, 'Ars longa vita brevis. Altar
Decoration and the Salvation of the Soul in
the Seventeenth Century', *Jaarboek Koninklijk
Museum voor Schone Kunsten*, 2010, pp. 85–111.

A. Houbaert, *Lexikon van de Belgische
Minderbroederskloosters*, Brussels 2002.

L. Huet and J. Grieten, *Nicolaas Rockox,
1560–1640: burgemeester van de Gouden Eeuw*,
Antwerp 2010.

A. Jansen and C. Van Herck, 'Archief in
beeld. Het meubilair van onze abdijen en
kloosterkerken. (Naar oude tekeningen)',
Tijdschrift voor geschiedenis en folklore 10
(1947), pp. 5–67.

J. R. Judson, *Rubens, The Passion of Christ*
(Corpus Rubenianum Ludwig Burchard, VI),
Turnhout and London 2000.

J.B. Knipping, 'De laatste communie van
Sint Franciscus van Assisië', *Paneel en doek* 1
(Leiden 1949), no. 3.

A. Monballieu, 'Bij de iconografie van het
Rockoxepitafium', *Jaarboek Koninklijk Museum
voor Schone Kunsten Antwerpen*, 1970,
pp. 133–55.

A. Monballieu, 'De reconstructie van een
drieluik van Adriaen Thomasz. Keij bestemd
voor het hoogaltaar van de Antwerpse
Recollettenkerk', *Jaarboek Koninklijk Museum
voor Schone Kunsten Antwerpen*, 1971,
pp. 91–104.

A. Mossel, 'Christus en de ongelovige
Thomas. Iconologische opmerkingen bij
enige afbeeldingen van na de Reformatie',
Rubensbulletin 4 (2012), pp. 52–71.

H. Ooms, 'Grafkapellen in de voormalige
minderbroederskerk van Antwerpen',
Franciscana 50 (1995), pp. 33–51.

D. Papebrochius, *Annales Antverpienses ab
urbe condita ad annum 1700 collecti ex ipsius
civitatis monumentis*, Antwerp 1845–48.

A. Sanderus, *Chorographia sacra Brabantiae
sive celebrium aliquot in ea provincia
ecclesiarum et coenobiorum descriptio*,
Brussels 1659.

W. Savelsberg, 'Die Darstellung des heiligen
Franziskus von Assisi in der flämischen
Malerei und Grafik des späten 16. und
17. Jahrhundert', *Iconographia Franciscana* 6
(Rome 1992).

S. Schoutens (O.F.M.), *Geschiedenis van
het voormalig minderbroedersklooster van
Antwerpen: (1446–1797)*, Antwerp 1908.

C. Van Herck, 'De Antwerpse barok
biechtstoelen', *Jaarboek Koninklijke
Oudheidkundige Kring van Antwerpen*, 1953,
pp. 13–94.

H. Vlieghe, *Saints* (Corpus Rubenianum
Ludwig Burchard, VIII), Brussels, London and
New York 1972–73.

L. Wuyts, 'Het barokke hoogaltaar van
de voormalige minderbroederskerk te
Antwerpen: een iconologische benadering',
in *Liber memorialis Erik Duverger. Bijdragen
tot de kunstgeschiedenis van de Nederlanden*,
Wetteren 2006, pp. 557–87.

The Abbey Church of St Michael's

44

Cornelis Galle, after Hendrik van Balen
St Norbert and the Blessed Waltman, 17th century.
Engraving, 506 × 367 mm.
Norbertine Abbey, Averbode

The Abbey Church of St Michael's
can be made out in the background
beneath the monstrance.

▶ 45

Lucas Vorsterman the Younger,
after Iohannes Peeters
St Michael's Abbey from the east, 17th century.
Engraving, 365 × 495 mm.
Norbertine Abbey, Grimbergen

On account of its resemblance to the garden screen
of the Rubens House, the gate of St Michael's Abbey
(foreground) is sometimes attributed to Rubens.

The antique-lovers and bargain-hunters browsing the little shops on Antwerp's Kloosterstraat probably do not realize that this was once the site of one of Antwerp's oldest and most powerful religious institutions. Only the street-names now recall St Michael's Abbey, the proud tower of which was a prominent waterfront landmark: apart from Kloosterstraat itself ('convent street'), there are Sint-Michielskaai and Sint-Michielsstraat ('St Michael's quay' and 'St Michael's street').

The church's location next to the river meant that its public entrance was situated somewhat unusually on the east side of the building. A monumental Baroque gateway, crowned with an impressive statue of the abbey's patron saint, led into a large courtyard. The church itself was then entered via two doorways leading into the ambulatory to the rear of the high altar. The design of the imposing entrance gate is sometimes attributed to Rubens himself, because of its resemblance to the portico of his house on the Wapper, now The Rubens House museum.

The abbey proper was situated to the south of the church, while the distinctive tower stood to the north – a square lower section with belfry windows, rising to a polygonal structure and topped with an onion-shaped roof. The complex was surrounded by a host of smaller buildings and ornamental gardens, giving it the appearance of a grand estate, which is hard to imagine in the modern, fully built-up urban context.

History

The abbey was founded in 1124, when Bishop Burchard of Cambrai granted Antwerp's first parish church, dedicated to the Archangel Michael, to St Norbert and the local canons. A new chapter devoted to the Holy Virgin was created for the existing canons of St Michael's,

who took with them the parish rights to what would later become Our Lady's Cathedral. A member of the Norbertine community, the Blessed Waltman, was appointed the first abbot of St Michael's, which went on to become one of the most powerful religious institutions in the Low Countries, with numerous offshoots, including foundations at Middelburg, Averbode and Tongerlo.

The abbey's illustrious history also reflected the presence within its walls of the 'Prinsenhof', or prince's residence. The Cardinal Infante Ferdinand (1609–1641), for instance, stayed there during his Joyous Entry in 1635. The last in a series of triumphal arches was erected at the entrance to the abbey, which was the final destination for his procession through the city streets. Other prominent guests of the abbey included Tsar Peter the Great (1717), Charles Alexander of Lorraine (1744) and Louis XV (1746).

The institution flourished in the seventeenth century, as witnessed by near-continuous work to fit out the church and the abbey buildings. The abbey also boasted an impressive library and supported important publications like the *Acta Sanctorum*, while members of the community itself, among them Abbot Johannes Chrysostomos van der Sterre (abbacy 1629–52) published important works in their own right. The abbey prospered in

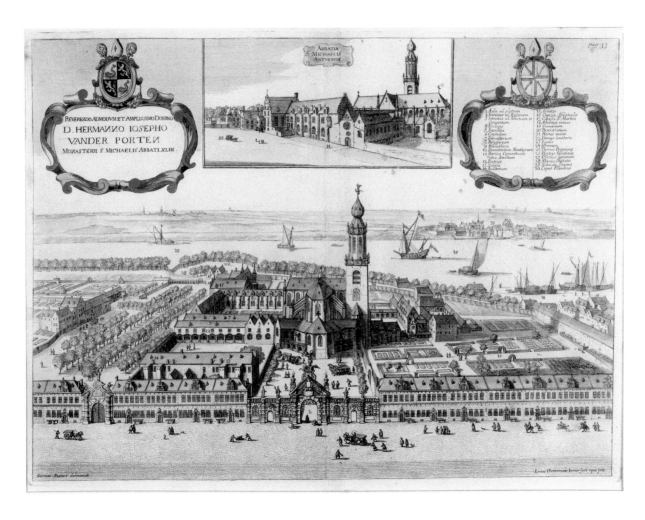

46 | 47

Gustave Simonau
The Entrepôt in the former Church of St Michael's Abbey and the Arsenal in Kloosterstraat after the bombardment of Antwerp in 1830, 19th century.
Engravings, 210 × 305 mm and 207 × 305 mm.
Museum Vleeshuis, Antwerp

48

Attributed to Jan Brueghel the Elder
St Michael's Abbey from the west.
Drawing, 205 × 318 mm.
Museum Plantin-Moretus/Prentenkabinet,
Antwerp, inv. PK.OT.00326

more worldly terms too. In 1674, for instance, Charles II made Abbot Simeomo lord of Zandvliet and Berendrecht, and the abbots also had a seat in the States of Brabant.

The abbey was expropriated in 1796 during the French revolutionary occupation and its buildings and all its goods were auctioned off in 1797. The canons entertained the brief hope that they might be permitted to return to the abbey following Napoleon's concordat with the Pope in 1801, but Bonaparte decided otherwise, giving the order in 1803 for the abbey and its church to be used as a shipyard and administrative centre for the navy. The abbey was subsequently used as a warehouse in the period of the United Kingdom of the Netherlands (1815–30) and the entire complex 46–47 was burned out on 28 October 1830, during the Dutch bombardment of Antwerp. The ruins were progressively cleared in the course

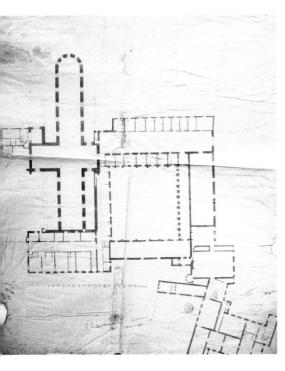

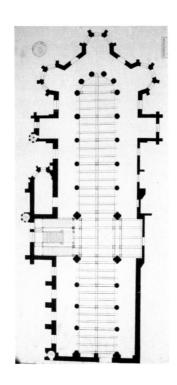

◄◄ 49
Anonymous
Plan of St Michael's
Abbey, c.1800.
FelixArchief, Antwerp,
inv. 12 5236

◄ 50
Anonymous
Plan of the Abbey Church
of St Michael's, c.1800.
FelixArchief, Antwerp,
inv. 12 5410

of the nineteenth century and nothing now
remains of the abbey buildings. The works
of art that decorated its magnificent interior
were either lost or dispersed following their
public sale during the French period.

Building

Construction of the first St Michael's
Church probably began just after the abbey's
foundation in 1125. It suffered the collapse
of its tower in 1241 and a new one, located
above the northern aisle of the choir, was not
completed for over a century, in 1354. The
church had a crypt, which was uncovered
in the nineteenth century and was located
on the north side of the new church, the
Romanesque building having made way
after 1401 for a Gothic one, complete with
ambulatory and three ambulatory chapels.

The choir was finished in 1420. The
second round of construction was completed
around 1470, with the final touches to the
transept and nave. The result was a church

51

Virgilius Bononiensis
and Gillis Coppens van Diest
Map of Antwerp, 1565 (detail).
Museum Plantin-Moretus/Prentenkabinet,
Antwerp, inv. MPM.V.VI.01.002

View of St Michael's Abbey from the west.

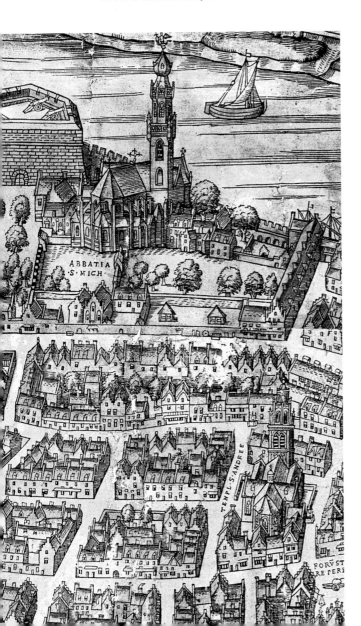

50 featuring a chancel with five bays and a chevet, making it larger than the nave, which had only four bays. In other words, the function as abbey church was central to the structure of the building. The two public entrances from the courtyard to the east were located between the three ambulatory chapels. The building had two other unusual features: the south part of the transept was omitted and the aisle on that side had no windows. Given the secondary importance of the church's west entrance, its facade on that side was very simple in design. This part of the abbey faced the city walls, which ran along the bank of the Scheldt, and could not be accessed from outside.

The church was struck by disaster at various points in its history. Its needle spire was struck by lightning, for instance, in 1501, and was replaced four years later with a new 51 tower, this time topped with an onion spire. The crossing tower was also badly damaged by a fire in 1525 but it was not repaired. The church also suffered wilful destruction on several occasions during the turbulent sixteenth century, beginning with the Iconoclastic Fury of 1566. This was followed by the 'Spanish Fury' in 1576 and then a period under Lutheran control (1581–85). Not only did the institution's historical fabric suffer during all this, the number of canons also declined painfully. According to Floris Prims, the material and spiritual state of the abbey deteriorated to such an extent that Bishop Laevinus Torrentius (1587–95) thought of dissolving it, but ran into opposition from the civic authorities.

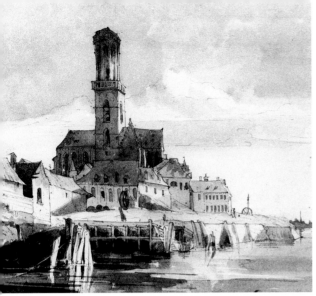

52

C. Abingdon
*St Michael's Abbey
from the north*, 1815.
Watercolour, 217 × 289 mm.
Museum Wuyts-Van Campen
& Baron Caroly, Lier

◀ 53

Philip van Bree
*The Ruins of the Entrepôt,
the former St Michael's Abbey,
in Antwerp*, 1830.
Canvas, 56 × 47.5 cm.
MAS, Antwerp, inv. AV.7338

65

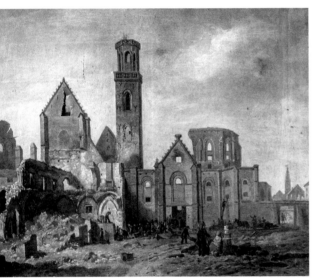

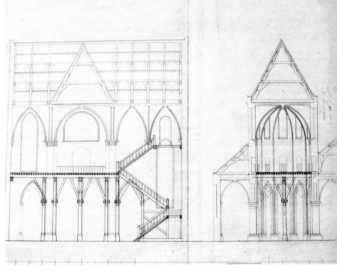

54 | 55 ▶

Anonymous
Cross-sections of the Church of
St Michael's Abbey, c. 1800.
FelixArchief, Antwerp,
inv. 12 5392 and 12 5411

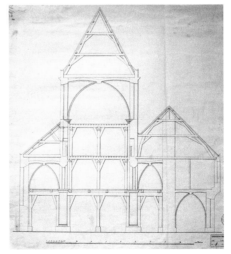

Unlike the other churches discussed in this book, several visual sources have survived showing us the interior of the Premonstratensian Church in Antwerp. Sadly, Rubens's *Adoration of the Magi* is not visible in any of them. Two works – a painting by

57 Pieter Neeffs the Elder (c. 1578–after 1658), signed and dated 1658 on the tombstone in the foreground, and a 1694 engraving by

61 Hendrik Causé (1648–1699), published in the *Acta sanctorum Iunii* – give us a detailed view of the church's nave. A small painting by Hubertus Quellinus (1619–1687) – son of the sculptor Erasmus the Elder and younger brother of Artus Quellinus the Elder, also a

58 sculptor – meanwhile shows the rood screen. We only know of Quellinus's work, however, from a small reproduction in a 1933 auction catalogue, which states that it was signed and dated, but not unfortunately what that date was. Each of these sources is rendered with

56F great visual detail, but the monumental rood screen obscures our view of the high altar's retable.

But worshippers too might not have seen that impressive construction immediately either, since the easiest way into the fifteenth-

56A century Gothic church was via the ambulatory. Following that route, churchgoers will first

56B have seen the back of the high altar before

56D walking past the deep choir, where the liturgy was celebrated, and only then entering the

56K narrow two-aisled nave. Since there were no altars in this part of the church, it had an open appearance that differed from that of the cathedral, say, in which the numerous altarpieces make the space seem cluttered. The floor was tiled in a black and white pattern interspersed by a great many tombstones. There were no windows in the south aisle, which adjoined the abbey buildings.

The only object standing in this open area was the pulpit – a splendid piece of

work completed in 1628 on the order of Abbot Mattheus van Iersel (Irsselius;

62 abbacy 1614–29). The body of the pulpit was decorated with the symbols of the four Evangelists – lion, eagle, angel and ox – and was supported by personifications of the three 'theological virtues', Faith, Hope and Charity. The latter, whose gossamer, classicizing robes make them seem almost like nymphs, are identifiable from their attributes – a book, an anchor and a torch respectively. The large sounding board was 'supported' by two seraphim, while two cherubim at the top held an image of the Virgin Mary.

The work has been attributed on stylistic grounds to Erasmus Quellinus the Elder, father of the celebrated sculptor Artus Quellinus the Elder. The two men produced a very similar design for the Church of St Gummarus in Lier (1640–42). Much of the St Michael's pulpit found its way into the former St James's Church in 's-Hertogenbosch, in the Netherlands, although the sounding board, supporting angels and stairs were replaced with new elements. According to the then prior and later abbot Johannes Chrysostomos van der Sterre, there was nothing in Antwerp to match the pulpit's architecture and sculpture (although he may have deliberately overlooked the admittedly more sober one that the Jesuits had installed in their brand-new church the previous year).

The walls of the aisles had wood panelling with benches that filled the spaces between several confessionals. The latter were very simple in design. They were completely open, with just some abstract decoration on the shallow panels on either side of the confessor's central space. Two later confessionals dating from the 1670s ended up at St Trudo's in

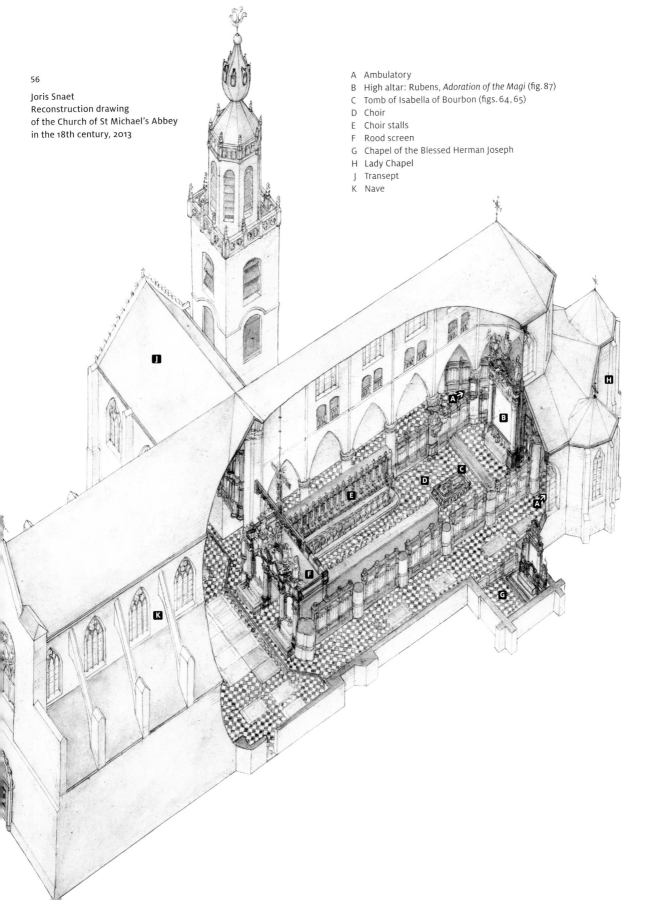

56

Joris Snaet
Reconstruction drawing
of the Church of St Michael's Abbey
in the 18th century, 2013

A Ambulatory
B High altar: Rubens, *Adoration of the Magi* (fig. 87)
C Tomb of Isabella of Bourbon (figs. 64, 65)
D Choir
E Choir stalls
F Rood screen
G Chapel of the Blessed Herman Joseph
H Lady Chapel
J Transept
K Nave

57

Pieter Neeffs the Elder
Interior of the Abbey Church of St Michael's, 1658.
Panel, 38.5 × 52.5 cm.
Private collection

58

Hubertus Quellinus
Interior of the Abbey Church of St Michael's, after 1665.
Canvas, 74 x 68 cm.
Present whereabouts unknown [photograph RKD, The Hague]

Zundert. One of them can be seen in Causé's
67 engraving, replacing the one shown in the
Neeffs painting. The space for the confessor
is flanked by two angel herms, while those
for the confessants are bounded by twisted
columns.

On the south side, adjoining the abbey
buildings, several paintings decorated the
various bays of the aisle's blind wall. In this
case too we notice a difference between the
sources. Neeffs's painting, done in 1658,
features a *Lamentation over the Dead Christ*,
for instance, and the memorial painting of
Prior Cornelis Standock (d. 1590), showing
the donor kneeling before the cross. The late-
seventeenth-century interior illustrated by
61 Causé, by contrast, shows three enormous
paintings (approx. 350 × 460 cm) with
episodes from the life of the Martyrs of
Gorkum, nineteen of whom were killed in
1572 by Protestant forces during the revolt
against Spanish rule. Two of those who
died were Norbertines. The paintings were

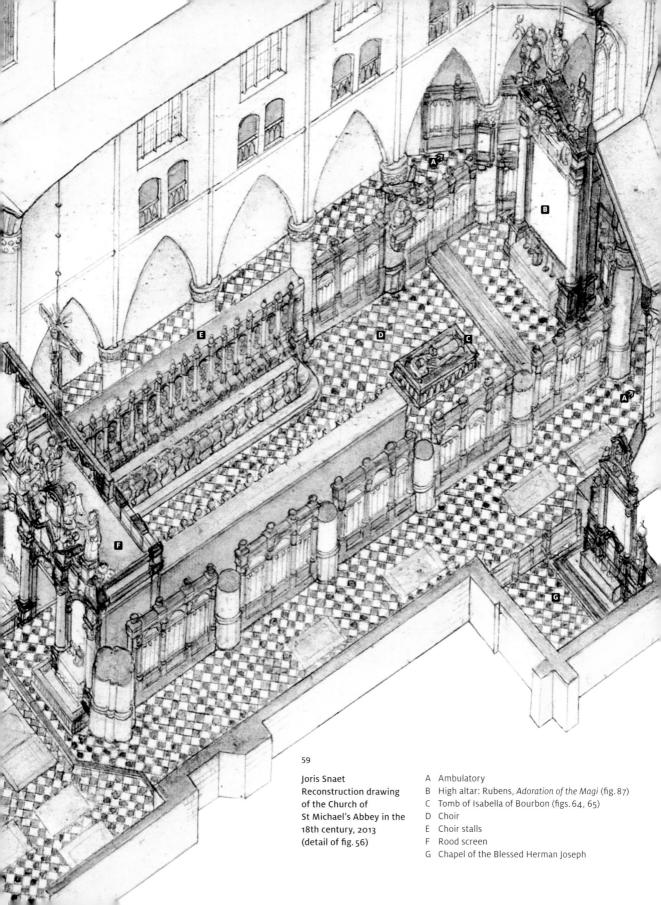

59

Joris Snaet
Reconstruction drawing
of the Church of
St Michael's Abbey in the
18th century, 2013
(detail of fig. 56)

A Ambulatory
B High altar: Rubens, *Adoration of the Magi* (fig. 87)
C Tomb of Isabella of Bourbon (figs. 64, 65)
D Choir
E Choir stalls
F Rood screen
G Chapel of the Blessed Herman Joseph

60

Anonymous drawing after the Epitaph
of Abbot Waltman in the Abbey Church
of St Michael's, 18th century?
FelixArchief, Antwerp, inv. GF 324,
fol. 41

61

Hendrik Causé
*Interior of the Abbey Church of
St Michael's*, c.1694.
Engraving in *Acta sanctorum Junii ex
Latinis et Graecis, aliarumque gentium
antiquis monumentis, servatâ primigeniâ
scriptorum phrasi, collecta, digesta,
commentariis et observationibus*, vol.1,
Antwerp 1695.

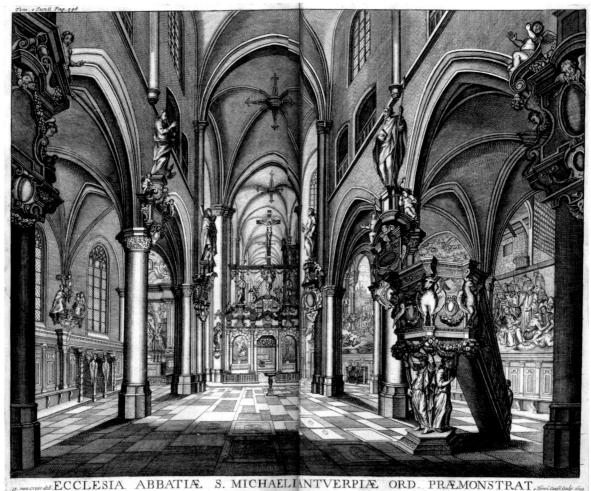

ECCLESIA ABBATIÆ S. MICHAELI ANTVERPIÆ ORD. PRÆMONSTRAT.

commissioned from Jan Erasmus Quellinus (1634–1715) on the martyrs' beatification. The only one to survive is now in the Norbertine abbey in Tongerlo.

The most important feature in the north aisle was the white marble memorial to Waltman, the first abbot (1124–38), which was installed by Abbot Johannes Chrysostomos van der Sterre, probably in 1638 to mark the five-hundredth anniversary of his predecessor's death. The now-lost memorial comprised a carved image of the prelate kneeling in prayer before the Virgin and Child and has been attributed, like the rood screen, to Hans van Mildert. The central place occupied by the Virgin Mary in the iconography of this unusual memorial is interesting. By showing her in the company of their first prelate, the abbey laid claim as it were to Marian worship in Antwerp, highlighting itself as a centuries-old institution with an impeccable track record in that regard. This unmistakable message has to be viewed against the background of new orders, such as the Jesuits, which had similar ambitions of their own.

It was not the only sculptural ensemble adorning the public section of the abbey church: a complete series of the apostles stood against the columns of the central aisle. It was the custom in the seventeenth-century Southern Netherlands to decorate the pillars of large churches with carved images of Christ's first followers, reflecting

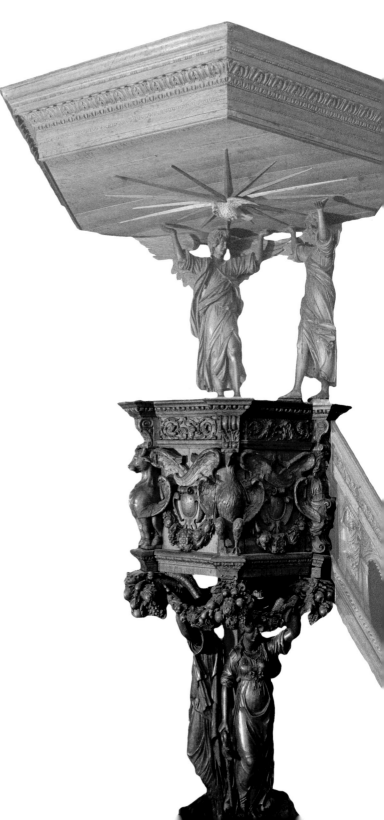

62

Attributed to
Erasmus Quellinus the Elder
Pulpit of the Abbey Church
of St Michael's, 1628.
Jheronimus Bosch Art Center
(former St James's Church,
's-Hertogenbosch)

The tester supported by angels
and the stair are not original.

63

Hans van Mildert
St Peter, before 1638.
Alabaster, approx. 200 cm.
Cathedral of Our Lady,
Antwerp

The two surviving statues that
once crowned the pediment of
the rood screen in the abbey
church (see fig. 61) are now in
Antwerp Cathedral.

the view of the apostles as the pillars on
which the Catholic Church rested. In most
cases, the sculptures had a commemorative
function, with benefactors funding them
as memorials. These endowments were
identified by inscriptions on the bases of the
statues in the form of large cartouches, with
opulent scrollwork. By contributing to the
decoration of the church's interior in this
way – something viewed as a form of charity
on the part of wealthy believers – they were
also contributing to their personal salvation,
for which they could now also count on the
special intercession of the represented saint.
In some cases, portraits of the donors were
included in the inscribed tablet.

The rood screen was undoubtedly the
59F central visual focus in the public part
of the church interior, not least because
of the barrier it formed between the lay
congregation and the choir where the high
altar – the focal point of the church interior
– was located. The rood screen, between
the two pillars flanking the entrance to the
choir, had three bays, decorated in an opulent
Baroque style. Each of the two outermost bays
also housed an altar: devoted to the Sacred
Cross on the left and to St Michael, the abbey's
patron saint, on the right. The painter of the
altarpieces is not known. The central bay was
occupied by a doorway leading into the choir,
which is open in all the visual sources and
therefore must have provided churchgoers
59B with a clear view of the high altar featuring
Rubens's *Adoration of the Magi*.

The partition was topped with a balustrade
placed behind three broken segmental
pediments corresponding with the three bays,
each conceived as a portico. Cartouches in
the middle of each of the pediments served as
the base for a statue. The figure in the centre
was the *Pastor Bonus* – the Good Shepherd,
or Christ carrying a sheep on his shoulders –
flanked by two seraphim kneeling in worship.
One of the latter collected the blood from

63 the wound in Christ's side in a cup. St Peter stood atop the pediment on the left, holding the keys to heaven, and St Paul with his sword on the right. Together with the figures in the nave of the church, they represented the thirteen apostles: the twelve original disciples, excluding Judas, plus the latter's replacement, Matthew, and the honorary apostle Paul. Cherubim holding laurel wreaths and palm branches sat below them on the members of the broken pediments.

As customary since the Middle Ages, there was a triumphal cross above all this, resting on a cross-beam and – as can be
57 seen in Neeffs's picture – accompanied by two other sculptures, presumably the Mother of God and St John. The partition replaced an earlier Gothic rood screen, which had been badly damaged as far back as the iconoclastic violence of 1566. The new one was installed during the abbacy of Johannes Chrysostomos van der Sterre, possibly in the early 1630s. The death of the sculptor and architect Hans van Mildert in 1638 provides a likely *terminus ante quem*. We know that he made the figures of the two apostle princes, Peter and Paul, thanks to the

testimony of Antonius Sanderus (1586–1664). Sanderus published a book on the abbey and its holdings in 1660, in which he attributed the sculptures in question to 'the hand and extraordinary art of Johannes van Mildert'. According to Frans Baudouin, the structure – like the retable for the high altar – might have been designed by Rubens, a hypothesis based on similarities he detected with the portico of the Rubens House. Nothing has survived of the rood screen other than the two apostle figures – marvellous alabaster
63 sculptures now in Antwerp Cathedral.

Churchgoers who glanced through the central doorway in the choir will have seen an exceptional monument in front of the high altar. This was the old tomb
59c of Isabella of Bourbon (1436–1465), with
64 a fine effigy and several cast bronze tomb figures (*pleurants* or 'weepers'). Charles the Bold's wife died in 1465 while staying at the Prinsenhof. She was travelling south from Gorkum (Gorinchem) in the County of Holland, probably to meet her husband in France. The Norbertine Abbey in Antwerp was to be her unexpected final resting place. Isabella's daughter, Mary of Burgundy,

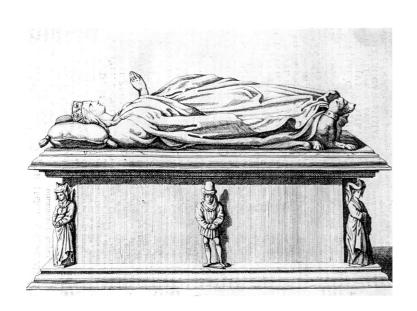

64

Anonymous
The Tomb of Isabella of Bourbon (1476–78), c.1859.
Engraving in P. Génard, *Verzameling der graf- en gedenkschriften van de provincie Antwerp*, 1856–1905, vol. 4

Attributed to Jan Borman II
and Renier van Thienen the Elder
Pleurants of the tomb of Isabella of Bourbon, 1475–76.
Bronze, height 54.5–58 cm.
Rijksmuseum, Amsterdam, inv. BK-AM-33A-J

ordered the construction some years later of a monument to her late mother. The bronze effigy and the other tomb figures have been ascribed to Renier van Thienen the Elder (d. before 1498). The monument ended up in Antwerp Cathedral following the French Revolution, and has recently been loaned to M - Museum Leuven. The *pleurants* are now in the Rijksmuseum in Amsterdam.

65

As indicated already by the many memorials and the funerary character of the statues forming the apostle series, the abbey church owed an important part of its layout to its function as a burial place. Even though the institution had no parish duties to fulfil, the abbey had managed to retain the funeral rights of the former parish of St Michael's, with the result that the centuries-old abbey church became the final resting place of many prominent Antwerp citizens.

A large retable is visible on the east side of the north transept in the views by Neeffs and Causé. This was the altar of the Chapel of the Holy Sacrament. Rubens installed a memorial to his mother here in 1608, following his return from Italy and her death. He donated a commemorative painting of his own, *The Virgin and Child with St Gregory and other saints*. It was done originally for Santa Maria in Vallicella in Rome, but was rejected by its patrons. The painting was incorporated in a marvellous marble retable presumably by Artus Quellinus the Younger (1625–1700), and both elements can be clearly distinguished in Causé's engraving. The marble portico and associated communion bench are now in Antwerp Cathedral.

57
61

68

66

67

The same chapel contained other memorials to the illustrious dead. To begin with, it was the resting place of two other members of the Rubens family: not only the city clerk Johannes (Jan) Brant (d. 1639), father of Rubens's first wife, Isabella, but also the artist's brother, the former municipal secretary Philip Rubens (d. 1611).

66 ▶

Attributed to Artus Quellinus the Younger
Reredos of the Sacrament Chapel
from the Abbey Church of St Michael's, c.1667.
Onze-Lieve-Vrouwekathedraal, Antwerp

After the demolition of St Michael's Abbey
several of its monumental portico altars
found a new location in other churches
(see also figs. 74, 75, 81).

67

Hendrik Causé
Interior of the Abbey Church of St Michael's,
c.1694 (detail of fig. 61)

View of the altar of the Sacrament Chapel with
Rubens's altarpiece.

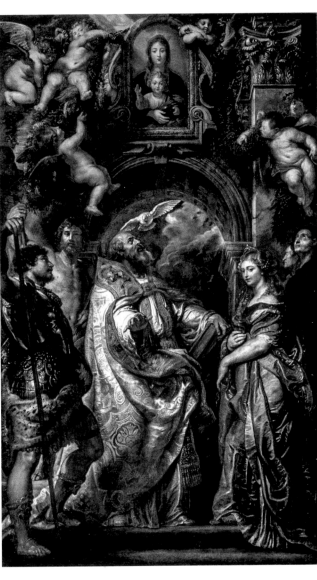

68 ▶

Peter Paul Rubens
The Virgin and Child with St Gregory and other saints, 1607.
Canvas, 477 × 288 cm.
Musée des Beaux-Arts, Grenoble, inv. 97

69

Cornelis de Vos
*The Citizens of Antwerp Bringing the Monstrance
and Sacred Vessels Hidden from Tanchelm
to St Norbert*, 1630 (detail of fig. 7).
Koninklijk Museum voor Schone Kunsten,
Antwerp, inv. 107

Nicolaas Rockox attentively observes the viewer
from the background. The Norbertine canon seen
in profile next to the mitred St Norbert may be
Abbot Van der Sterre. The kneeling donor on the
right is considered by some to be the famous art
collector Peeter Stevens (1605–before 1669).

The commemorative plaque from this memorial was later mounted in the wall of the garden at the Rubens House Museum. The Detroit Institute of Arts has a portrait that Rubens made of his brother, which is believed to have formed part of the memorial in St Michael's Abbey.

The memorial painting of Nicolaas Snoeck (d. 1607), his wife Catharina van Uytrecht (d. 1630) and their family members, features none other than Nicolaas Rockox, who, standing alongside St Norbert, gazes out of the background straight at the viewer. Some historians, meanwhile, have identified the kneeling man in the foreground who presents Norbert with the monstrance as the wealthy cloth merchant and passionate art collector Peeter Stevens. The Norbertine canon whom we see in profile next to the founder of his order might be Abbot Van der Sterre. The painting, by Cornelis de Vos (1584–1651), depicts a very unusual theme: *The Citizens of Antwerp Bringing the Monstrance and Sacred Vessels Hidden from Tanchelm to St Norbert.* We make out St Michael's Abbey and the tower of the cathedral in the background. Placing the scene anachronistically in the seventeenth century will have emphasized the importance of the Premonstratensians in the defence of the Eucharist not only in the twelfth century but also in the contemporary context of the religious controversy with the Protestants. Katlijne Van der Stichelen believes that the Norbertine looking at the viewer could be Johannes Snoeck, son of the memorialized couple, and a canon at the abbey, who might have commissioned the work in 1630.

In addition to relatives of Rubens and the Snoeck family, the chapel housed the tomb of the world-famous cartographer and geographer Abraham Ortelius (1527–1598). His wall epitaph was decorated with sculptures of two Virtues and a Risen

70

Peter Paul Rubens
Philip Rubens, 1611–12.
Panel, 68.5 × 54 cm.
Detroit Institute of Arts, inv. 26.385

71

Anonymous drawing after the Epitaph of Abraham Ortelius, 18th century?
FelixArchief, Antwerp, inv. GF 324, fol. 70

72

Gerard Seghers
The Virgin and Child Presenting the Order's Habit to St Norbert. Canvas, 193.7 × 146 cm.
Koninklijk Museum voor Schone Kunsten, Antwerp, inv. 513

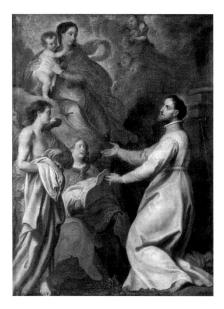

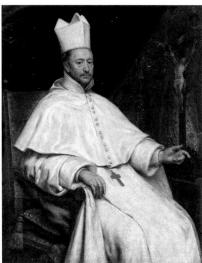

73

Katharina Pepijn
Norbertus van Couwerven, Abbot of St Michael's Abbey, 1657.
Canvas, 130 × 106 cm.
Koninklijk Museum voor Schone Kunsten, Antwerp, inv. 873

Christ, a profile portrait and a globe. The latter two objects are now in the collection of the Museum aan de Stroom (MAS) in Antwerp.

Apart from the Chapel of the Holy Sacrament, the one dedicated to St Norbert – located opposite the north entrance to the canons' choir – was undoubtedly the most important of the six side-chapels. It was home to an impressive silver shrine purchased by Abbot Norbertus van Couwerven (abbacy 1652–61) in 1654 to house relics of the order's founder. The reliquary featured a depiction of the saint's arrival in Antwerp on the bank of the river Scheldt, also set anachronistically in the seventeenth century, with the tower of the cathedral in the background. The prelate paid the astonishing sum of 10,914 florins for the chest. There was a work by Gerard Seghers (1591–1651) on the altar: *The Virgin and Child Presenting the Order's Habit to St Norbert*, which has been dated on stylistic grounds to the second half of the 1620s.

The next chapel a visitor would have seen on the north side was dedicated to St John the Baptist. There was an appropriate painting on the altar of the *Baptism of Christ*, to which contemporary sources did not ascribe any great artistic merit. The Lady Chapel was located to the rear of the high altar, between the two church entrances. The portico altar, now in Zundert in the Netherlands, features the arms of Abbot Norbertus van Couwerven and so must have been made in the period 1652–61. It is by Philip Fruytiers (1610–1666) and shows the Virgin of the Immaculate Conception, being beseeched for peace. The marble frame and sculpture are said by an eighteenth-century witness to have been the work of Artus Quellinus the Younger.

The next chapel on the south side of the ambulatory was devoted to St Anne. Its altarpiece was long thought lost, but was identified in the early 1990s by Dorothea Bieneck, biographer of Gerard Seghers, in the sacristy of St Andrew's Church in Antwerp.

It shows Mary being instructed by her mother, in the presence of her father, St Joachim, and Sts Catherine and Barbara. Bieneck dates the work to the final decade of the painter's life.

The final chapel on the south side of the ambulatory was that of the Blessed 59 G Herman Joseph – another important figure in the Premonstratensian Order. The marble setting and the altarpiece itself 75 ended up in Zundert, like the Altar of Our Lady. Jacob de Wit attributed the frame to Artus Quellinus the Younger, while the altarpiece has been ascribed to his son Jan Erasmus Quellinus. The painting shows the *Mystical Marriage of Herman Joseph with the Holy Virgin*. The cornice of the portico incorporates the arms of Abbot 76 Macarius Simeomo, who may therefore be identified as the commissioner of the overall ensemble. His abbacy ran from 1661 to 1676. A signed and dated design drawing for the altarpiece has survived, enabling us to pin its construction down to precisely 1675.

Another element of this chapel's fittings survived the French period, namely the monument to a fifteenth-century dignitary, the governor of Lille, Antoine d'Ongnies, who died on 19 March 1478. The tomb, with its *gisant* or recumbent statue of the deceased, came 80 from a niche in the chapel's exterior wall. The damaged effigy now belongs to the 77 collection of the Vleeshuis in Antwerp.

We have no information, sadly, about the abbey church's former choir 59 E stalls. Memorials to former abbots were installed against the pillars of the choir incorporating portraits of them, in the form of either paintings or busts. Two examples featuring portrait busts of Gerard 78, 79 Knyff (1682–87) and Jan-Baptist Vermoelen (1716–32) are now in the Church of St Fredegandus in Deurne.

74

Attributed to Artus Quellinus II
Portico altar from the Lady Chapel in the Abbey Church of St Michael, 1652–61.
Church of St Trudo, Zundert

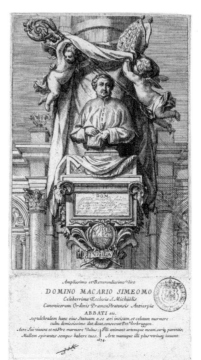

75

Attributed to Artus Quellinus II
Portico altar from the Chapel of the Blessed Herman Joseph in the Abbey Church of St Michael, 1661–76.
Church of St Trudo, Zundert

76

Anonymous
Epitaph of Abbot Macarius Simeomo, c.1674.
Engraving.
FelixArchief, Antwerp, inv. 12 5270

77

Anonymous
Effigy from the tomb of
Antoine d'Ongnies, c. 1478.
Stone, 206 × 104 × 28 cm.
Museum Vleeshuis, Antwerp

78 | 79

Anonymous
Epitaphs of abbots Gerard Knyff
and Jan-Baptist Vermoelen,
after 1687 and after 1732,
respectively.
Church of St Fredegandus, Deurne

80 ▶

Anonymous drawing after the
tomb of Antoine d'Ongnies,
18th century?
FelixArchief, Antwerp,
inv. GF 324, fol. 65v

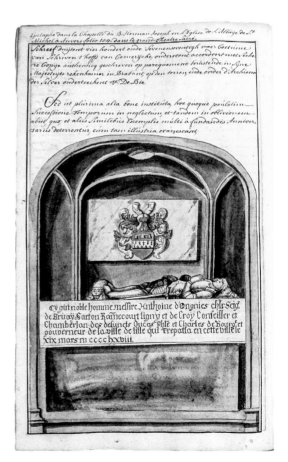

The abbey's church and other buildings were once again damaged by fire in 1620. As part of the subsequent refurbishment, Abbot Mattheus van Iersel (Irsselius; 1541–1629) installed a new high altar retable around 1624. This was five hundred years after the abbey's foundation, a momentous anniversary that may partially explain the grandiose nature of the commission. We are not informed, sadly, as to precisely why Abbot Irsselius chose Rubens, although the artist did have a close relationship with the abbey church. His mother, Maria Pypelinckx, had sold the family home on the Meir in 1601 and moved to Kloosterstraat. When she died in 1608, she was interred in the Church of St Michael's

70 Abbey. In 1611 Rubens's brother Philip was also buried in the abbey church. But the Norbertine community shared Rubens's joys as well as his sorrows, for example in 1609, when he married his first wife, Isabella Brant, in St Michael's.

In the autumn of 1610, Rubens presented the church with the *Virgin and Child with*
68 *St Gregory and other saints* – an altarpiece that had been rejected by the Oratorian Fathers in Rome – as a memorial to his late mother. With this prestigious gift, he saw to it that a monumental work by his own hand was given a prominent place in an important Antwerp church. It was an astute move for an artist who had just achieved the status of court painter and who was trying to gain a foothold among ecclesiastical patrons in Antwerp. At this point, the only altarpiece by his hand displayed in a publicly accessible space was the *Disputation of the Holy Sacrament* (c. 1609). Rubens had made this work, which is rather modest in size, for the sacrament altar in the Dominican Church. The *Adoration of the Magi* for the States Chamber at the City Hall (1609; now Prado, Madrid), and the *Annunciation* (c. 1609–10; now Kunsthistorisches Museum,

Vienna) for the chapel of the Sodality of Married Men, were only viewable by a limited public. It was not until the summer of 1610 that Rubens signed the contract for his first high altarpiece in Antwerp, the celebrated *Raising of the Cross* for St Walburga's Church.

Rubens received a first payment of 750 florins on 23 December 1624 – the year in which he was raised to the nobility – for supplying an altarpiece with the *Adoration*
87 *of the Magi*. A second instalment followed for a similar amount on 29 August 1626, two months after the premature death of his wife Isabella. The painting was intended to
59B adorn the high altar at St Michael's, to which end it was provided with a magnificent architectural frame comprising a miniature portico in black and red marble, topped with three monumental alabaster sculptures representing St Michael, the Holy Virgin and St Norbert. Rubens probably designed this part of the monumental commission too – oil sketches by his hand have certainly survived
85, 86 with models for two of the three sculptures. The setting for Rubens's altarpiece might have been made by the Antwerp sculptor
81 and architect Hans van Mildert, with whom the painter had previously collaborated on similar commissions.

No specific details are known regarding the creation of the marble portico and sculptures, though it may reasonably be supposed that its construction too had to be completed by Christmas 1624, just like the altarpiece. This probably explains the unsubstantiated date (1620) given by Jacobus van der Sanden, who presumably took that year's fire as his point of reference, and the tentative 1622 ventured by I. Leyssens, who attributed the portico to Hans van Mildert. It is also true, however, that certain comparable constructions in this period – the high altarpiece for Antwerp Cathedral,

for instance – experienced a difficult birth, due to financial and technical issues. We cannot rule out the possibility therefore that the altarpiece was installed in a temporary mounting in order to mark the five hundredth anniversary and that the marble portico was not installed until a later date. Leyssens rightly offers as *terminus ante quem* the description of the ensemble in Abbot Van der Sterre's *Echo S Norberti triumphantis ...*, which was published in 1629.

Having functioned for the best part of two centuries as the magnificent focal point of the abbey church's interior, this imposing *Gesamtkunstwerk* also fell victim to the revolutionary French occupation of the Low Countries, at which point the painting and its marble setting went their separate ways. In 1815 the painting entered the collection of the Koninklijk Museum's precursor, while the architectural frame was purchased by the parish council in Zundert, just over the border in the Netherlands.

The fact that Rubens more than likely also designed the costly marble structure in which his painting was mounted makes the work even more exceptional. Rubens's thinking

81

Attributed to Hans van Mildert
Portico of the high altar from the Abbey Church
of St Michael's, c. 1624. Church of St Trudo, Zundert

Situation before 1927.

82 | 83 | 84

Attributed to Hans van Mildert
St Michael, the Virgin and Child and St Norbert, c. 1624.
Alabaster, life-size.
Church of St Trudo, Zundert

The three statues came from the reredos of the
high altar in the Abbey Church of St Michael.

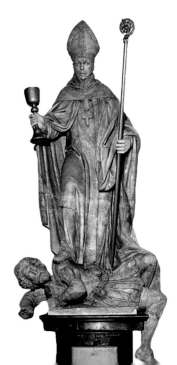

85

Peter Paul Rubens
St Norbert, c.1624.
Oil sketch: panel, 66.5 × 46 cm.
Private collection

86

Peter Paul Rubens
St Michael, c.1624.
Oil sketch: panel, 64.8 × 49.6 cm.
Private collection

St Norbert and *St Michael* are the two
surviving oil sketches that served Hans
van Mildert as the models for the life-size
statues on the portico of the high altar
(figs. 81, 82, 84).

in this regard was frequently innovative,
and this was no exception. The placement
of three monumental alabaster statues at
the three corners of the pediment at the top,
reflecting classical acroteria, is not only
unique in the Southern Netherlands, it must
also have cost a fortune.

 The way the *Adoration* is presented
is an outlier in Rubens's own oeuvre too.
The master painted the theme many times
in the course of his career, with examples
now found in Madrid (Prado, 1609); Mechelen
(St John's, 1616–17); Lyon (Musée des Beaux-
Arts, 1618–19); Brussels (Musées royaux
des Beaux-Arts de Belgique, c. 1619); Paris
(Louvre, 1626–27); Cambridge (King's College
Chapel, 1633–34); and Potsdam (Bildergalerie
Sanssouci). Certain motifs in the Antwerp
Adoration occur rarely, if at all, elsewhere

82–84

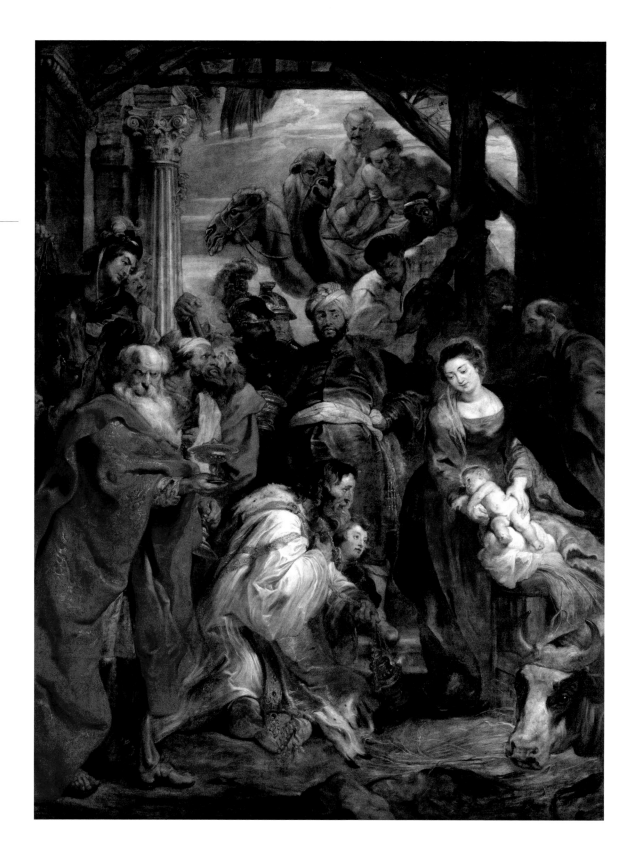

and seem designed to lend extra weight to the central theme – the Eucharistic sacrifice of Christ that brings salvation to humanity. This is the case with the ears of wheat, which refer to the Host, and the box, which serves as a crib and refers to the altar. The prominent presence of the camels, recalling Noah's Ark, and of an unnatural light in both the foreground and background (dawn?) may be read as a symbol of the Advent of Christ. It is also the case, lastly, that the depiction of the Moorish king – not only a much-discussed theme among theologians, but one in which Rubens was especially interested as well – is unique in his oeuvre. In other Adoration scenes, for instance, the painter bases himself on life studies of a young black model. Here he drew on the exotic features of a sixteenth-century Berber prince and sometime ally of Emperor Charles V, known as the King of Tunis, Mulay Ahmed, which he combined with the body of an imposing male figure dressed in the Turkish manner.

An oil sketch in the Wallace Collection in London is very likely part of the preparatory work for the Antwerp altarpiece. Close comparison with the final painting reveals several major adjustments, possibly made at the patron's request. A first series of adaptations emphasizes once again the Eucharistic perspective of the scene and its significance within the story of the Salvation. The psychological distance from the Christ Child, to whom the oldest Greek or Western king presents a dish of gold pieces in the design, has been increased.

In the altarpiece, the Saviour is wafted with incense by the Assyrian or Oriental king. The liturgical nature of this action is stressed by the change in the robes he wears, which now comprise a surplice and stola. The addition of the ox in the right foreground, one of the most important sacrificial animals in the Bible, which gazes steadily at the viewer, is a further allusion to Christ's sacrifice. It is

also striking how the animal is made, as it were, the counterpart of the elderly Greek king in the red cloak, who stares at us just as penetratingly. The classical pillar flanking a dilapidated structure possibly alludes to the palace of King David, from whose old kingdom the new kingdom would rise. The damaged spider's web in the stable roof, lastly, might symbolize the victory over evil represented by the coming of the Redeemer.

Iconographical tweaks of this kind not only emphasize the Eucharistic dimension of the scene, they also heighten the focus on the Virgin Mary. The oil sketch shows her partly with her back to the worshipper, whereas

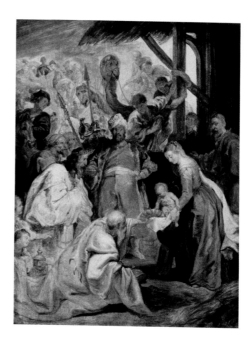

88

Peter Paul Rubens
The Adoration of the Magi, c. 1624.
Oil sketch: panel, 63.6 × 48.3 cm.
The Wallace Collection, London, inv. P519

Design for the high altarpiece of the Abbey Church of St Michael's (fig. 87).

◀ 87

Peter Paul Rubens. *The Adoration of the Magi*, c. 1624.
Panel, 447 × 336 cm. Koninklijk Museum voor Schone Kunsten, Antwerp, inv. 298

in the altarpiece itself she appears frontally, standing behind the box and supporting her son, whom she presents as it were to the kings and the onlookers. The result adds visual weight to her role as *Virgo sacerdos* (priestess) and *Co-Redemptrix*. The Madonna was given an even more prominent role in the ornamentation at the top of the retable construction, in which she occupies the central position, despite the fact that St Michael was the abbey's patron saint and it was customary in the seventeenth century to place an image of the altar's patron saint in this position of honour.

These striking changes and the unusual content of the overall retable decoration suggest that the commission must have come about in an exceptional context, and recent research has also prompted several new lines of thought in that regard. It was already known that there was a specific material

need at the time of the commission for new altar decoration. Not only did the church interior still bear the scars of its stripping during the period of Protestant rule, the building also suffered a major fire in 1620. It is less well known that the abbey also had two major anniversaries to celebrate in that period – that of the foundation of the Premonstratensian Order in 1121, and the foundation of St Michael's Abbey itself in 1124. Explicit reference to the order's foundation was made, incidentally, in the crypt beneath the high altar, which contained a second Adoration scene, by analogy with the high altarpiece, showing the first members of the Norbertine Order taking their vows on Christmas night 1121, and seeing a vision of the Christ Child.

Study of the physical context of the high altar shows, moreover, that the commission had an important funerary aspect too. Abbot

89

Peter Paul Rubens
Mattheus Irsselius, Abbot of St Michael's Abbey, c. 1624.
Panel, 120 x 102.5 cm.
Statens Museum for Kunst, Copenhagen, inv. KMSSP 191

90

Abraham van Diepenbeeck
Johannes Chrysostomos van der Sterre, Abbot of St Michael's Abbey, before 1675. Canvas, 125.9 × 106.8 cm.
Private collection

Mattheus Irsselius, the actual patron, was eventually buried in front of the high altar, as was his then prior and future successor Johannes Chrysostomos van der Sterre, who might have acted as adviser on the commission. It is highly likely, moreover, that their respective portraits – painted by Rubens and Abraham van Diepenbeeck (1596–1675) – were installed on either side of the altar, their gaze as it were directed in eternal adoration of the 'events' being played out on the high altar.

89,90

In addition to these new contextual details, further explanation was needed for the exceptionally explicit Marian and Eucharistic character of the iconographic programme, beyond the general backdrop of the Counter-Reformation. The order's statutes – as published in 1631, for instance – promote the *cultus eucharisticus* and *cultus marianus* as authentic, twelfth-century Norbertine values. Van der Sterre also stated explicitly that Mary ought to be seen as the patroness of the abbey church.

Close reading of these contemporary texts, especially Van der Sterre's, gives the impression that the striking confluence of Norbertine devotional objectives with Counter-Reformation focuses such as the veneration of the Virgin did not happen by chance. It is as though Van der Sterre were trying to appropriate these elements for the Premonstratensians, using the centuries-old nature of their spiritual identity as an authoritative argument. That there was a need for such devotional 'marketing' ought to be seen against the backdrop of evolving religious life in Antwerp, in which new and 'ambitious' orders like the Jesuits were vying for Catholics' loyalty. The fact that the ancient Abbey of St Michael felt the need to consolidate and strengthen its position in this devotional landscape is also apparent in the parallel – unsuccessful – attempts of Abbot Irsselius to translate the remains of the order's founder, St Norbert – that 'most excellent champion ... of this Holy Sacrament' – to Antwerp.

91

91

Abraham van Diepenbeeck
St Norbert of Prémontré, 1634.
Canvas, 180 × 150 cm.
Cathedral of Our Lady, Antwerp

SOURCES

Antwerp, FelixArchief, PK 171–173,
J. van der Sanden, Oud Konst-Toneel
van Antwerpen.

Antwerp, FelixArchief, GF 324,
Graf- en gedenkschriften van Antwerpse
kerken.

LITERATURE

Acta sanctorum Iunii ex Latinis et Graecis …,
vol.1, Antwerp 1695.

P. Baudouin et al., Onze-Lieve-Vrouwe-
kathedraal van Antwerpen. Kunstpatrimonium
van het ancien régime (ed. S. Grieten
& J. Bungeneers) (Inventaris van het
kunstpatrimonium van de provincie
Antwerpen, 3), Turnhout 1996.

J. C. Diercxsens, Antverpia christo nascens et
crescens, vol.1, Antwerp 1773.

P. Génard, Verhandeling over S. Michielsabdy
te Antwerpen (Inscriptions funéraires et
monumentales de la province d'Anvers:
arrondissement d'Anvers. Verzameling der
graf- en gedenkschriften van de provincie
Antwerpen, 4), Antwerp 1859.

B. Haeger, 'Rubens's Adoration of the
Magi and the Program for the high Altar
of Sint-Michael's Abbey in Antwerp',
Simiolus. Kunsthistorisch tijdschrift 25 (1997),
pp. 45–71.

B. Haeger, 'Abbot van der Sterre and
St Michael's Abbey: the Restoration of its
Church, its Image, and its Place in Antwerp',
in K. Van der Stighelen et al., Sponsors of the
Past – Flemish Art and Patronage, 1550–1700
(Museums at the Crossroads, 11), Turnhout
2005, pp.157–79.

B. Haeger, 'The Choir Screen at Sint-
Michael's Abbey in Antwerp: Gateway to the
heavenly Jerusalem', Munuscula Amicorum.
Contributions on Rubens and his Colleagues
in Honour of Hans Vlieghe (Pictura Nova, 10),
Turnhout 2006, pp.527–46.

V. Herremans, 'De Aanbidding door de
Koningen (Pieter Paul Rubens, ca.1624)
uit de Antwerpse Sint-Michielsabdij in het
Koninklijk Museum voor Schone Kunsten
Antwerpen: recente onderzoeksresultaten',
Analecta Praemonstratensia 86 (2010),
pp.276–84.

V. Herremans, '"Opus vere basilicum &
stupendum." Devotionele profilering en
persoonlijk zielenheil: de inrichting van
het hoogkoor van de Antwerpse Sint-
Michielsabdij en de abten Mattheus Irsselius
(1541–1629) en Johannes Chrysostomos
van der Sterre (1591–1652)', Rubensbulletin
(online) 2 (2008), pp.5–35. www.kmska.be/
nl/Onderzoek/Rubens/Rubensbulletin_2.
html

I. Leyssens, 'Hans van Mildert 158?–1638
levensbeschrijving', Gentse Bijdragen tot de
Kunstgeschiedenis 7 (1941).

J. R. Martin, The Decorations for the Pompa
Introitus Ferdinandi (Corpus Rubenianum
Ludwig Burchard, XVI), Brussels 1972.

F. Prims, De geschiedenis van Antwerpen. VIII.
Met Spanje (1555–1715), Antwerp 1943.

M. Rooses, L'Œuvre de P.P. Rubens: histoire
et description de ses tableaux et dessins,
Antwerp 1886–92.

A. Sanderus, Chorographia sacra coenobii
S. Michaelis Antverpiae, Brussels 1660.

J. Van den Nieuwenhuizen, Abbaye de
Saint-Michel à Anvers (Monasticon belge, 8),
Liège 1992.

D. Van de Perre, 'Middeleeuwse
premonstratenzer sites en kerken',
Werkgroep Norbertijner Geschiedenis in de
Nederlanden. Bijdragen van de contactdag 9
(Brussels 1999), pp.9–56.

K. J. Vander Eyken, De St.-Michielsabdij
Antwerpen. Iconografische tentoonstelling
1124–1830, Antwerp 1988.

J. C. van der Sterre, Echo S. Norberti
triumphantis, sive commentarius eorum,
quae ab Antverpiana S. Michaelis
Praemonstratensium Canonicorum Ecclesia,
tam pro impetrandis SS. Norberti…. Reliquiis;
quam pro iisdem… excipiendis, peracta sunt …,
Antwerp 1629.

K. Van der Stighelen, Portretten van Cornelis
de Vos (1584/5–1651): een kritische catalogus
(Verhandelingen van de Koninklijke
Academie voor Wetenschappen, Letteren
en Schone Kunsten van België: Klasse der
Schone Kunsten, 51), Brussels 1990.

92
Peter Paul Rubens
The Adoration of the Magi, c.1624
(detail of fig.87).
Koninklijk Museum voor
Schone Kunsten, Antwerp, inv.298

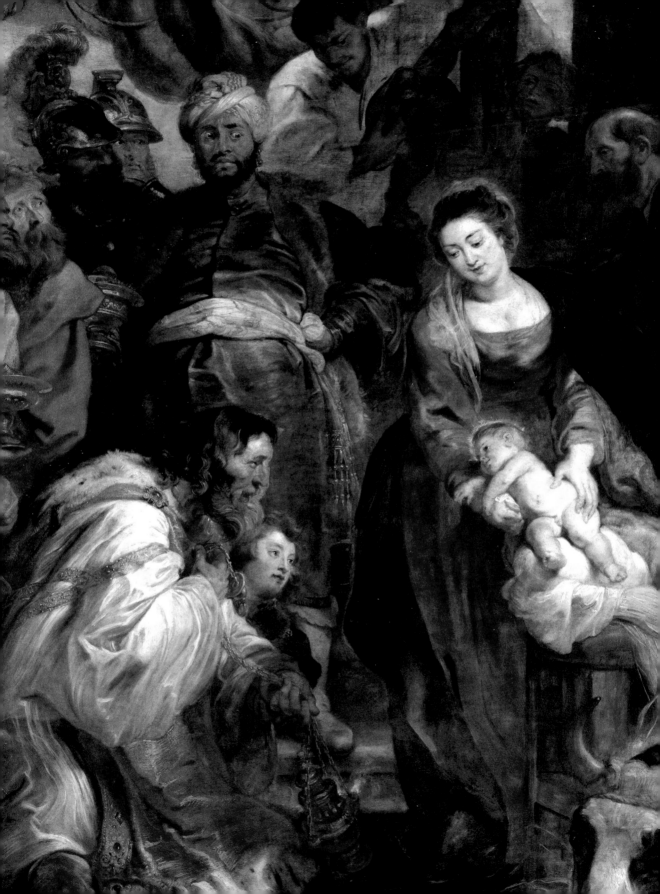

The Church of the Calced Carmelites

The entrance gate leading via a narrow alleyway to the former Church of the Calced Carmelites or Brothers of Our Lady, stood opposite what is now Groendalstraat, a side-street off Huidevetterstraat. The building was also accessible on the north side via another little path running from the Meir. The church marked the northern boundary of the abbey buildings, which stood on a parcel of land formed by the Meir, Huidevetterstraat, Jodenstraat and the Wapper, roughly where the Sint-Norbertusinstituut, the former Sint-Jan Berchmanscollege, now stands. Whenever Rubens left his home on the Wapper, he will have been able to glance at the church's choir and bell towers, which rose above the surrounding houses. The Convent of the Calced Carmelites was located in a district whose residents consisted for the most part of wealthy burghers, many of them successful businesspeople.

History

The foundation of the Carmelite monastery in Antwerp was not always smooth. The Carmelites of Mechelen held the right since 1408 to beg and provide assistance in Antwerp, to which end they based themselves at a refuge in Huidevetterstraat. When the occupying French were driven out of Flanders in 1479, Mary of Burgundy was obliged to keep her promise to build a monastery for the order in Antwerp, if her husband Maximilian of Austria were to emerge victorious. The Chapter of Our Lady and the civic authorities refused, however, to grant permission, not least because their consent would have entailed a financial commitment they simply could not meet at that time, as priority had to be given to building the cathedral and funding military operations.

93

Pieter Verbiest II
Map of Antwerp, c.1662
(detail of fig. 4).
FelixArchief, Antwerp, inv. 12 5832

View of the convents of the Calced and Discalced Carmelites from the west.

94

Anonymous
The Carmelite Church.
Drawing from an album with illustrations of Antwerp churches, 17th century?
Museum Plantin-Moretus/ Prentenkabinet, Antwerp, inv. s213

The friars refused to give up. They attempted to start building an abbey in 1486 and again in 1493, only for the chapter to consistently withhold its approval. It was eventually agreed that no large-scale building work would begin before 1498 and that divine services would be limited. The convent's foundation was ultimately dated to 1494, with actual construction work beginning in 1498.

Revolutionary French troops forcibly entered the convent on 11 November 1794 to demand its silver and gold, but the friars had already removed their famous silver Madonna statue and gold monstrance to a place of safety. The indignant French responded by closing the complex on 28 November and ordering the monks to move in with their near-relatives, the Discalced or 'Barefoot' Carmelites. The next day, all the works of art were moved into the choir for storage and the church was pressed into service as a 'Temple of Reason'. The Carmelites made several unsuccessful attempts to reoccupy their buildings but the church was eventually auctioned off. Through an intermediary, it came into the possession of *Jonkheer* Pierre de Meulenaer, who had it demolished so that he could sell the building materials. The same minor nobleman was responsible for the demolition of the minster in Tongerlo and St George's Church in Antwerp. Some of the monastery's buildings served for a while as warehouses. From 1891 the neo-Gothic complex of Sint-Jan Berchmanscollege was built on the site.

Building

The history of the church's construction was a very long one. The choir was consecrated in 1512 by Jean Brisselot, the suffragan bishop of Cambrai. A side-chapel with an altar dedicated to Our Lady of the Seven Sorrows, founded by Pedro Lopez, was then consecrated in 1525. The chapel was

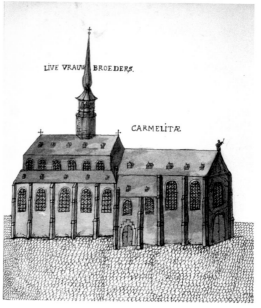

located on the north side of the choir, which is clearly visible in the 1565 city plan
97 of Virgilius Bononiensis. The friars then suspended their building activities until after the Fall of Antwerp in 1586, following which the choir was enlarged and work began on the transept and nave in 1606. The transept and four altars were consecrated in 1614, and
96 the building as a whole was completed in
95 1622. According to a nineteenth-century plan, the church – which could be seen from the Meir – was roughly 63 metres long and about 24 metres wide at the aisles.

Jan de Garavelle started work in 1615 on an additional chapel devoted to the Virgin. This was the 'Rosa Mystica Chapel', named for one of Mary's titles in the Litany of Loreto, supposedly because Garavelle's coat of arms included a rose in the first and fourth quarter. It was also known as the Chapel of Our Lady of the Scapular, as the fraternity of that name, founded in 1629, was also based there. The annex adjoined the west side of the Chapel of Our Lady of the Seven Sorrows.

Other benefactors of the monastery, the carpet merchant Alexander van der Goes and his wife, the wealthy merchant's daughter Maria della Faille, paid for the church's facade, which Tine Meganck has shown to

95

Anonymous
Plan of the Carmelite Convent
with indication of its works of art,
19th century.
FelixArchief, Antwerp, inv. 12 5427

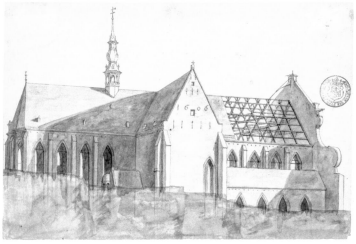

96

Anonymous
The Carmelite Church from the north-east.
Drawing.
FelixArchief, Antwerp, inv. 12 5282

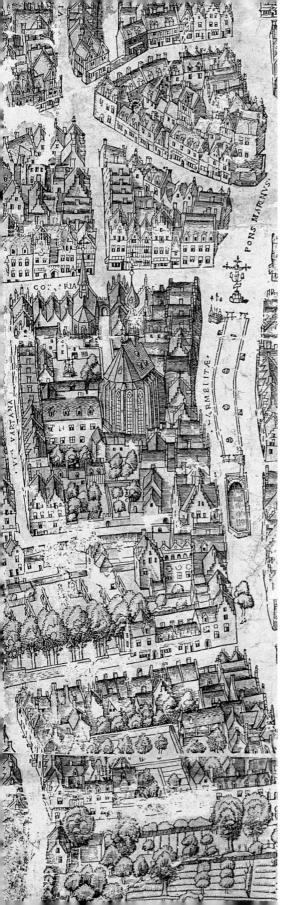

have been designed by the court architect
100 Wenceslas Cobergher (1557/61–1634). It
used to be said in Antwerp that the Van der
Goes family was as rich as the water of the
golden well in their coat of arms was deep,
so it comes as little surprise to learn that the
facade cost them more than thirty thousand
florins.

The building's appearance is well known
10, 98 thanks to several different sources, which
display only minor differences. It had
three bays with three entrances and three
windows. The donors' arms were installed
above the exterior windows. The facade
had a niche above its central window
containing an image of the Madonna,
and was surmounted by a statue of the
prophet Elijah, the legendary founder of
the Carmelite Order. Both works might have
been done by the sculptor-architect Robrecht
de Nole, who was one of the contractors
employed on the facade, and with whom
Cobergher also collaborated on the basilica
at Scherpenheuvel. Cobergher's highly
distinctive style, with its combination of
surfaces in brick and white stone for the
ornaments, framings and string courses, can
still be admired in Antwerp in the facade of
the Augustinian Church.

97

Virgilius Bononiensis and
Gillis Coppens van Diest
Map of Antwerp, 1565 (detail).
Museum Plantin-Moretus/Prentenkabinet,
Antwerp, inv. MPM.V.VI.01.002

View of the Carmelite Church from the east.
The wide street on the right is the Meir, still
one of Antwerp's main streets.

98

Lucas Vorsterman II
The Carmelite Convent from the west, c.1660.
Engraving.
FelixArchief, Antwerp,
inv. 12 5341

99

Thomas Rowlandson
The Meir in Antwerp, c.1794.
Hand-coloured engraving,
400 × 550 mm.
Private collection

The facade and spire of the Carmelite Church tower above the gabled houses of one of Antwerp's most elegant streets.

100

Anonymous
Facade of the Carmelite Church.
Engraving.
FelixArchief, Antwerp, inv. 12 5259

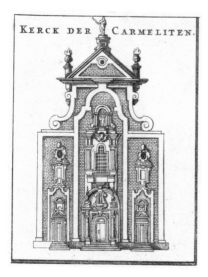

101

Peter Paul Rubens
*Portrait of a Carmelite monk
(Gaspar Rinckens?)*. Panel, 41 × 29 cm.
Museum Boijmans Van Beuningen,
Rotterdam, inv. 1739

As in the case of the Franciscan Church, no visual sources have been identified that show us the interior of the former Carmelite Church in Antwerp. We therefore have to rely once more on written testimony. There were just four altars in the public part of the church, which was relatively few for the time. What is more, two of them were only modest in size, as they formed part of the rood screen separating the choir from the rest of the church. The rood screen altar on the left was donated by Maria vanden Leemputten, widow of Leonard Rinckens, who died in 1610. The donor herself might have died just before 1618. The couple's son, Gaspar Rinckens, whose portrait was painted by Rubens himself, was prior of the convent. The altarpiece showed the Three Magi and was attributed to Hendrik van Balen (1574/75–1630; erroneously referred to as 'Van Daelen' in some sources). The altar on the right, devoted to the Holy Trinity, featured a work by Rubens that will be discussed in the next section.

The altar dedicated to the Holy Cross was located against the east wall of the north transept (no. 26 on the ground plan). The original altarpiece, a painting by Abraham Janssen of the *Lamentation of Christ*, was moved around 1700 to a location above the church's south entrance and is now in the Muzeum Narodowe in Warsaw. It was funded by the notary and alderman Egidius Fabri and his wife Magdalena van Woonsel. Fabri was not only a lover of art, but also a member of the chamber of rhetoric 'De Violieren'. And he was highly devout, too, having also joined the Fraternity of the Holy Scapular. Husband and wife were both buried in front of the altar. The altar itself was decorated with a painting on marble of the *Vera Icon* – the true face of Christ – incorporated in a magnificently gilded reliquary that was

Calced Carmelite Church

96

102

Joris Snaet
Reconstruction drawing of the Calced
Carmelite Church in the 18th century, 2013

A Rood screen
B Rubens, *Holy Trinity* (fig. 114)
C Choir stalls
D Choir
E High altarpiece: see Rubens's
 oil sketches figs. 104 and 105

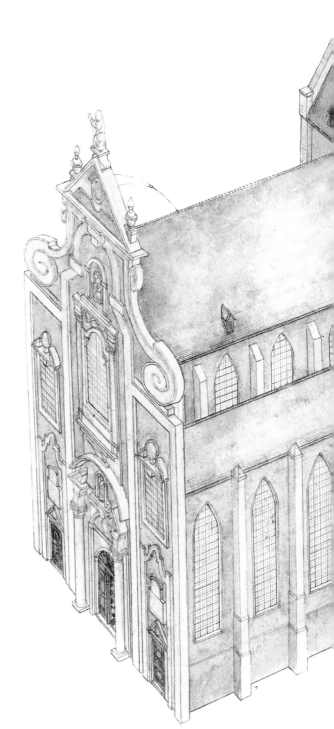

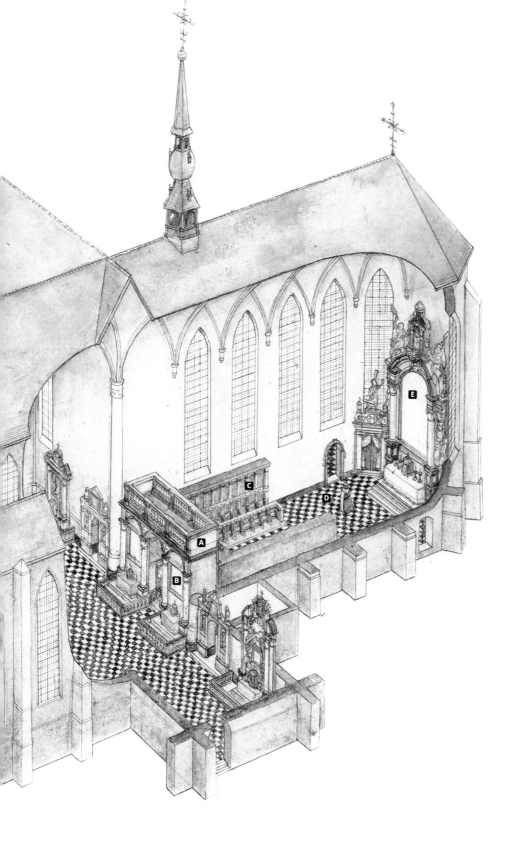

▶ 103

Gaspar Moens
Temporary festive decoration of
the high altar of the Carmelite
Church, 1732.
Drawing, 655 × 413 mm.
Museum Vleeshuis, Antwerp

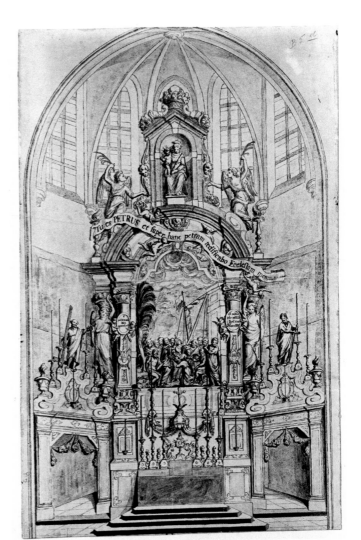

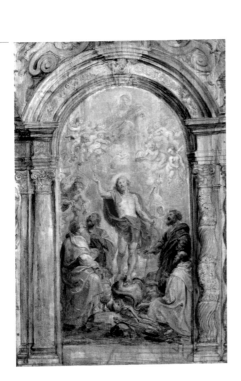

104

Peter Paul Rubens
The Glorification of the Eucharist, c. 1630?
Oil sketch: panel, 71.1 × 48.3 cm.
The Metropolitan Museum of Art, New York,
inv. 37.160.12

Design for the high altarpiece
of the Carmelite Church.

105

Peter Paul Rubens
Design for the high altarpiece
of the Carmelite Church?
Oil sketch: panel, 43.3 × 64.1 cm.
Rubenshuis, Antwerp, inv. S194

Presumed design for the crowning structure of
the reredos of the high altar.

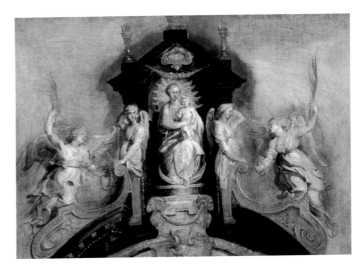

opened on specific feast days. This special painting, donated by Friar Jozef a Santa Maria, is said to have come from the collection of the Count Palatine of Neuburg.

106

In the equivalent position opposite was an altar devoted to Our Lady of Naples, which was also initially decorated by an Abraham Janssen painting. This *Virgo inter virgines* – the Virgin among female saints – is now in Lyon Cathedral. The painting was later replaced, possibly when Gaspar Melchior Moens (1698–1762) built two new altar porticoes, by two angel statues bearing a copy of the Santa Maria del Carmine, known as *La Vergine Bruna*. The scene was inspired by a Byzantine Madonna type, in which Mary tenderly embraces her son (*Glykophilousa*). Janssen's painting hung above the north entrance. The sculptor-architect Gaspar Moens, whose brother was a friar at the convent, trained under several masters including Jan-Pieter van Baurscheit the Younger (1699–1768).

Moens seems to have had close ties with the monastery, as he chose the Church of the Brothers of Our Lady as his final resting place. He was the author of a design for a temporary festive decoration for the monumental high altar in 1732, now in the Vleeshuis collection. This drawing offers evidence of the reredos of the high altar, the imposing dimensions of which must have made it a central focus in the church's interior. It was not only a large structure, but an unusual one too that differed somewhat from conventional norms for altar porticoes in that period, no doubt because Rubens himself not only designed the altarpiece but is documented as the designer of the portico as well. We know from two surviving oil sketches by Rubens that the two elements were designed as a single unit, although frustratingly each sketch presents only part of the ensemble. The oil sketch in the Rubens House, which has long been considered a design for the Jesuit

103

102 E

105

Church, shows the architectural and sculptural superstructure, while the one now in the Metropolitan Museum in New York depicts the central part of the portico with the altarpiece. One striking feature is the portico's cornice topped by a segmental arch, which connects with the rounded top of the altarpiece: most retable porticoes in this period simply featured a conventional, straight entablature.

104

117

Although Rubens designed the high altarpiece, he did not execute it himself. It was done by Gerard Seghers (1591–1651) around 1642, after Rubens's death. Nothing is known of the fate of Seghers's work in the wake of the French occupation in the late eighteenth century, leaving the New York sketch as the only testimony to it. It consisted of an allegorical presentation – once again unusual – of a complex iconographic theme: the *Triumph of the Eucharist*. Jean-Baptiste

106

Anonymous
Vera Effigies (Portrait of Christ).
Oil on marble, 38 × 32 cm.
Cathedral of Our Lady, Antwerp

S. Propheta ELIAS, inter miracula, S. Patritium à dæmonis vexa liberat.Mesonganus in
Vit. S. Patrit. cap. 19. Alium quemdam Nuritum nomine ab incurabili auricula sanat,
Iusutum(cui, ob periurium in loco ELIÆ Sacro, os et collum erat contortum)restituit.
Lezana Consulto 3. num. 116.

Descamps describes the subject in the following terms: 'The high altar in marble, very large and in rather good architectural taste, has a painting by G.[erard] Seghers … of a holy allegory; one sees God the Father and the Holy Spirit in Heaven, and Jesus Christ, holding his Cross in one hand and in the other a chalice on which is placed a host; Jesus Christ stands on the globe, trampling with his feet a skeleton and a serpent; in the lower part of the painting one sees St Peter and other saints.' Father Norbertus a Sancta Juliana identifies the subjects as 'Jesus Christ, Priest of the New Law, Author of the Holy Eucharist, with Melchizedek, the Prophet Elijah, the Apostle St Paul, and St Cyril, Patriarch of Alexandria.'

As was the case with Rubens's high altar in the Franciscan Church, the project here was endowed by a prominent couple, Felipe Godines and his wife Sebille vanden Berghe. Felipe Godines – also known later as Philippe de Goddines – may have been of Portuguese origin and was perhaps a *converso*, a Jew converted to Christianity. His mother, Inez Lopez, was a possible relative of Pedro Lopez, founder of the Chapel of Our Lady of the Seven Sorrows, whom we know for certain to have been a *converso*. The same was definitely the case for his namesake, who made his name in Spain in the first half of the seventeenth century as a dramatist.

The wealthy Godines, who was a royal tax collector, took possession of the castle and seigniory of Cantecroy – which included Mortsel and Edegem – on the bankruptcy in 1627 of the previous owner, Jan Baptist Maes. His will, drawn up on 23 December 1632, instructed his wife to install the altar on his death – barely a month later, as it turned out – in the church where he wished to be buried, allocating a sum of ten thousand florins for that purpose.

Execution of the stone portico was entrusted to the Van Mildert workshop, run by father Hans (1588–1638) and his son and

successor Cornelis (d. 1667). The altar steps were made by Hendrik-Frans Verbruggen (1654–1724), the 'prince of sculptor-designers', who was also responsible for the doorway to the sacristy, surmounted with a marble sculpture of the Prophet Elijah, and the impressive pulpit, supported by the figures of the four Church Fathers. The latter was donated to the Carmelites in 1678 by Pierre de Lannoy and his wife Gertrude Wouters. The benefactor might have belonged to the wealthy de Lannoy family of Antwerp merchants.

According to some accounts, including that of Jacob de Wit, a painting of the Prophet Elijah brandishing his sword, traditionally attributed to Rubens, hung above the central entrance, opposite the high altar. We do not know, however, of any work by Rubens on

107 that theme, nor does the engraving after the painting, now in Antwerp's FelixArchief, state that the original was by him. The work featured a complex iconography combining several of Elijah's miracles: St Patrick saved from the devil; the healing of Nurius's ear; and the healing of Iusufus, whose neck was twisted when he perjured himself.

The Chapel of the Fraternity of the
108 Scapular was a particular attraction drawing worshippers to the church. The brown scapular – the outer part of the robe worn by the Order of Our Lady of Mount Carmel – might be the oldest of its kind to be venerated. Its devotional use originated in a vision of St Simon Stock, a thirteenth-century English Carmelite, in which the Virgin Mary presented him with the scapular of the order, stating: 'This is for you and yours a privilege; the one who dies in it will be saved.' A reduced form of the scapular later became the privilege of the members of the Holy Scapular fraternity.

The chapel was also the burial place of its founder, the then municipal secretary Jan de Garavelle. A confidant of the Archdukes and member of the Secret Council, Garavelle was even appointed admiral of the Spanish

108

Franciscus Huberti
*The Silver Statue of Our Lady
of the Scapular in the Carmelite Church.*
Engraving. FelixArchief, Antwerp,
inv. 12 5287

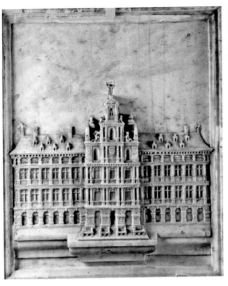

109 | 110 | 111

Pieter Scheemaeckers the Elder
The City Hall of Antwerp and the towers
of the Jesuit Church and the Cathedral.
Marble, 84 × 72.5 cm,
85 × 59 cm, 85 × 60.5 cm.
Museum Vleeshuis, Antwerp

Reliefs formerly adorning the Chapel of
Our Lady of the Scapular in the Carmelite
Church.

fleet in 1624. He was also exceptionally pious and preparing to enter the priesthood when he died in 1645. He consecrated the chapel himself and was duly buried there in a brown habit. Garavelle's support for the Calced Carmelites was a major boost for the friars as they were forced to vie with the newly arrived Discalced or 'Barefoot' Carmelites.

According to eighteenth-century sources, the dimensions of the chapel matched those of the chapel in Loreto, the famous site of Marian pilgrimage, where the so-called *Casa Santa* – the Virgin's house – miraculously appeared in Italy. Garavelle was certainly familiar with the location, as he made a pilgrimage to Rome and Loreto in 1604 following the early death of his first wife.

The interior was decorated with marble and black touchstone (lydite) and featured a barrel vault with copper gilt rosettes. No further decoration was added for several decades, when white marble reliefs by the Antwerp sculptor Pieter Scheemaeckers the Elder (1640–1714) were installed, showing the 'beauties of Antwerp'. Three of these unusual sculptures, representing the City Hall and the 109–11 towers of the Cathedral and the Jesuit Church, are now in the Vleeshuis Museum. According to Petrus Wemmers, these images represented

further honorifics of the Virgin Mary from the Litany of Loreto, possibly the Tower of David, the Ivory Tower and the Golden House. The chapel's altar was also made of white marble and contained a majestic silver Madonna figure no less than two metres in height, which cost Jan de Garavelle the immense sum of 16,000 florins. The consecration plaque for the Rosa Mystica Chapel is now kept at Sint-Norbertuscollege.

The spaces between the windows of the nave were decorated, as they had been in the previous, originally medieval church, by a series of paintings of themes important to the order. There were five paintings on either side, hanging above the confessionals. Most of them have since been lost, but one of the works in the series is now in Madrid: Pieter van Lint's (1609–1690) *Madonna Distributing Spiritual Gifts to the Carmelites.* On the feast of Our Lady of the Snow in 1288, the Virgin appeared at the request of Brother Xenus to three Carmelite friars in Mechelen, bestowing spiritual gifts on them symbolized by a rose, a blushing apple and a lily. Thanks to a surviving engraving, we can also identify the *Virgin Presenting the Scapular to Simon Stock and Prophesizing the Order's Perpetual Existence to St Peter Thomas,* painted by Jan Thomas (1617–1678). St Simon Stock, the sixth Prior General of the order, who received the Holy Scapular from the Virgin Mary on the night of 16 July 1251, is shown kneeling to the right of the Madonna, while St Peter Thomas, Patriarch of Constantinople, sits on the other side. Banderoles held by angels above the two clergymen's heads read: 'Chosen son, accept the Scapular of your Order, that those who wear it shall not know purgatory' and 'Have faith, Peter, that the Carmelite Order shall endure to the end of time.' The Mother of God was presented in the guise of *Madonna del Carmine* or *La Vergine Bruna.*

This was not the only decoration that must have given the aisles an exceptionally

112

Anonymous, after Jan Thomas. *The Virgin Presenting the Scapular to Simon Stock and Prophesizing the Order's Perpetual Existence to St Peter Thomas.*
Engraving. FelixArchief, Antwerp, inv. 12 5286

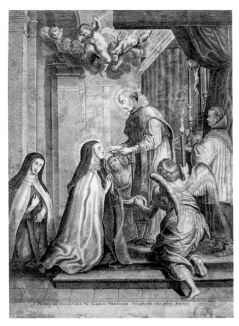

113

Anonymous, after Gerard Seghers
St Peter of Alcantara Administering Communion to St Theresa.
Engraving.
FelixArchief, Antwerp, inv. 12 5428

colourful and above all image-rich appearance. The stained-glass windows, showing scenes from the Life of the Virgin, were donated by wealthy citizens of Antwerp, such as Burgomaster Nicolaas Rockox, Godfried Houtappel and other dignitaries, including Bishop Johannes Malderus, who presented the *Coronation of the Virgin* in 1622. Philippe de Goddines, founder of the high altar, contributed the *Birth of the Virgin*. Two of the windows were attributed to the young Abraham van Diepenbeeck, who not only was a stained-glass artist, but also went on to become a celebrated painter and designer who was strongly influenced by Rubens. It might have been this particular commission – some authorities believe him to have been the author of all the windows in the series – that persuaded the artist to leave his native 's-Hertogenbosch and settle in Antwerp.

Gerard Seghers is said to have painted another work for the church that featured the rare theme of the Communion of St Theresa with her spiritual counsellor, St Peter of Alcantara. The painting, which was displayed on the west wall of the south transept, disappeared during the French period, but an 113 engraving of it survives, one impression of which is in the Antwerp municipal archives.

Another noteworthy work of art inside the church was the memorial in the south aisle to the painter Thomas Willeboirts Bosschaert (1613/14–1654), who died prematurely. A follower of Van Dyck, he stated his desire in his will to be buried in the Church of the Brothers of Our Lady, allocating 400 florins for a tomb and memorial. Some believe his marble monument to have been the work of Artus Quellinus, though it is unclear whether it would have been the Elder or the Younger (uncle and nephew). It incorporated two statues and a bust of the deceased. One of his paintings, the *Mystic Marriage of St Catherine*, hung next to it and might have been the work he bequeathed to the prior of the convent.

RUBENS'S *COMPASSIO PATRIS*: MOVING AND CONTESTED

Rubens's painting, originally in the Carmelite 114 Church and now in the museum collection, once prompted the following lyrical response from Jacobus van der Sanden, chronicler of Antwerp art in the eighteenth century: 'Sorrow can pierce a heart that loves God. For God the Father shows his beloved son on his lap, who has redeemed his grace through his death.' The beholder views Christ's dead body from a point level with his stretched-out legs. The shocking, naked corpse is the scene's monumental central motif. The effect must have been further heightened in the painting's original location by its position above the altar, which stood in turn at the top of three steps. The translucent, pale-blue body, wrapped only in a loincloth, is shown in impressive foreshortening. The fragile, dead Jesus lies on a shroud in his Father's lap, presented helplessly to the viewer's gaze. God the Father holds the end of the shroud in his left hand, creating a theatrical effect, while reaching out with his other hand to the viewer. Two cherubim on either side of the Father clasp the Instruments of the Passion with which the Son has been tortured to death, their sorrowful faces full of compassion. The scene is located above a mass of clouds, suggesting a celestial setting. A white dove representing the Holy Spirit flutters to the left of the Father's head.

The presence of the three divine figures tells us we are looking at a representation of the doctrine of the Holy Trinity, the depiction of which was a delicate issue in art history, as there are no clear indications as to its appearance. All manner of visual solutions have therefore been attempted through the ages. The work in which we are interested is based on the iconography known as the 'Mercy Seat' or 'Throne of Mercy'. God the Father, represented as an elderly man, supports the

114

Peter Paul Rubens
The Holy Trinity, c.1620?
Panel, 158 × 152 cm.
Koninklijk Museum voor
Schone Kunsten, Antwerp, inv. 314

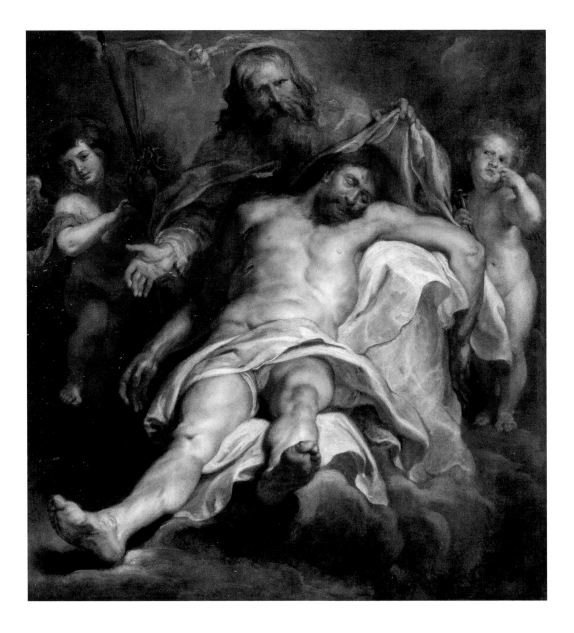

body of his crucified Son. The Holy Spirit is present with them in the shape of a dove. This is the *Compassio Patris* variant, in which the dead Christ lies in his father's lap. The other variant shows Christ on the cross, which stands before God the Father enthroned. The *Compassio Patris* motif arose around the same time as the theme centring on the suffering of the Mother of God: the Lamentation or Pietà, in which Mary holds her son's body on her lap.

It is hard to disagree with Van der Sanden's description of the moving, intimate character of the scene. Father and Son are presented in an exceptionally informal, human manner. One noteworthy feature determining the

'natural' character of the scene is the way Christ's feet are depicted, including their soles. This emphasizes the corpse's fragility and humility and makes it almost tangible. The rendering of Christ's right foot, the first part of the body the viewer sees, is especially remarkable: it is pushed, as it were, into the beholder's face, giving it a powerful repoussoir effect.

The explicit depiction of bare feet as a deliberate means of heightening the life-like character of the composition is something Rubens took from his Italian predecessors. The likes of Caravaggio (1571–1610) had, however, been roundly attacked for using

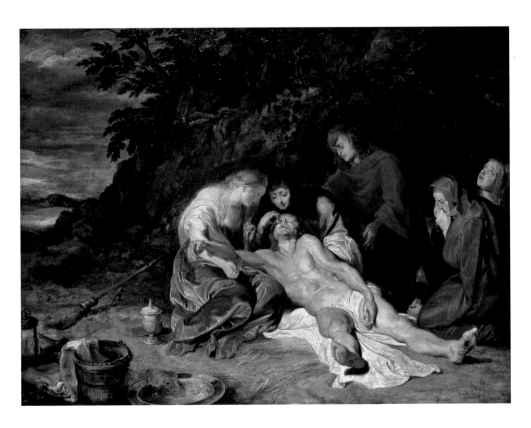

◀ 115
Peter Paul Rubens
The Holy Trinity, c. 1620?
(detail of fig. 114).
Koninklijk Museum voor Schone Kunsten,
Antwerp, inv. 314

116
Peter Paul Rubens
The Lamentation of Christ.
Panel, 55.2 × 74 cm. Koninklijk Museum
voor Schone Kunsten, Antwerp, inv. 319

such provocative imagery by contemporary art critics like Giovanni Pietro Bellori (1613–1696), who considered the portrayal in altarpieces of dirty feet – their soles are literally the 'lowest' part of the human anatomy – to be indecent, even when they belonged to poor pilgrims. Caravaggio also used the 'foot trick' in his *Madonna of the Rosary* (c. 1607), which was brought to St Paul's Church in Antwerp between 1617 and 1625 through the intermediary of Rubens himself, along with other painters such as Jan Brueghel the Elder (1568–1625) and Hendrik van Balen, and the connoisseur Jan Baptist Cooymans. It was subsequently replaced by a 1781 copy by Andreas de Quertenmont (1750–1835) and is now in the Kunsthistorisches Museum in Vienna. Rubens plainly drew on Caravaggio's painting for the bare shepherds' feet in his *Adoration* scenes in the former Jesuit Church in Neuburg and the Staatliche Kunstsammlungen in Kassel, both done around 1619–20.

Other Italian painters provided inspiration too: the motif of the feet and above all the powerful foreshortening of Christ's body are found in a painting of the *Lamentation* by another celebrated Italian artist who preceded Caravaggio: Andrea Mantegna (c. 1490; Pinacoteca di Brera, Milan), whose work Rubens knew very well from his time at the court of the Gonzagas. J. R. Judson believes that Rubens also had in mind the *Pietà* fresco in Cremona Cathedral by Giovanni Antonio de' Sacchis, known as Pordenone (c. 1483–1539), who was the great rival of Titian.

This was not the first time, however, that Rubens had presented Christ in this distinctive way: he used a similar composition for two versions of the *Lamentation* painted around 1613–14 (Liechtenstein Museum and Kunsthistorisches Museum, Vienna). The Koninklijk Museum has a copy after the painting in the Kunsthistorisches Museum. In this variation, Christ's body is less central than in the one in the Prince of Liechtenstein's

collection, which also recalls the *Holy Trinity* in this respect.

Rubens's *Holy Trinity* was funded by Judoca van der Capelle, of whom we know little beyond this particular benefaction. She was the daughter of Jan van Ieper and wife of Jan de Pape, an alderman of Antwerp. She died aged just thirty-one on 10 April 1621 and was buried in front of the altar she had endowed. Precisely when Judoca van der Capelle donated the altarpiece, and whether she did so during her life or in her will, is not known. Rudolf Oldenbourg has dated the work on stylistic grounds to about 1620. What we do know for certain is that the altar had already been consecrated in 1614. It was dedicated to the Archangel Michael and all the angels, Sts Anne, Mary Magdalene, Martha and Lazarus, all the Apostles and Evangelists, as well as to Sts Innocent and Boniface, whose relics were incorporated in the altar. It was certainly not unusual for an altar only to be provided with an altarpiece some time later, as the necessary funds were not always available immediately.

The inscription on the predella shows that the donor herself dedicated the altar to the Holy Trinity. Some historians have argued that her choice reflected a motif in her coat of arms – the clover-leaf, a traditional symbol of the Trinity. On the other hand, Trinity images of this kind – the so-called Throne of Mercy – had been a popular subject for memorials and for the private devotional scenes known as *Andachtsbilder* since the late Middle Ages, reflecting the underlying theme of mercy: humanity receives God's mercy or grace through Christ's sacrifice on the cross. The theme was also used to illustrate the canon of the mass in liturgical handbooks, as it summed up what was believed to happen during the Eucharist. God receives the body of his son as a sacrifice and offers it to the worshipper in return as salvation, hence the gesture God the Father makes in the painting, which suggests that gift.

Although this had been a much-loved iconographic theme in the Low Countries for hundreds of years, it did not enjoy the approval of Catholic thinkers on the eve of the seventeenth century. The celebrated Leuven theologian, Johannes Molanus (1533–1585), who wrote a treatise on religious imagery, was in no doubt: 'A learned priest wrote to me recently from Antwerp seeking advice. He asked me whether he should display a painting that had been donated to his church. It showed the naked, dead body of Our Lord, lying across [his Father's] lap, supported on his arms.... I responded that I could not approve of such an image, both because it is very unusual in God's church, and also for the following reason: nowhere is it written that Christ appeared in the form of a dead body – and also because I was convinced that his divinity was never separated from his body.'

The question arises as to why Molanus, who firmly rejected this manner of representation, should suggest that it was an unusual, deviant mode, as this was patently not the case. It had in fact been the most widespread way of depicting the Trinity since the fifteenth century. The theologian's rejection might have had something to do with the scene's central meaning, for the doctrine of grace was a highly controversial theme amid the sixteenth-century religious conflicts. Moreover, the iconography focuses entirely on salvation through 'sanctifying grace'. Major means for Catholics to achieve salvation, such as 'actual grace', free will and the practice of charity and good works, do not play a role of any importance in the subject.

SOURCES

Antwerp, FelixArchief, KK 576, *Chronographia sacra Carmeli Antverpiensis cuius in ortu antiquitas, in templo magnoficentia, in filiis virtus, in benefactoribus memoria, in eventibus singularitas illustrata a R.D. Antonio Sandero Gandensi canonico Iprensi nunc aucta et usque ad annum MDCCXLVI continuatur.*

Antwerp, Rubenianum, N[obertus] a Sancta Juliana, *Notitia succinta de ecclesia carmelitarum calceatorum Antverpiae / Description succinte de l'Eglise des Carmes Chaussés d'Anvers*, [18th century].

LITERATURE

H. Axel, *Thomas Willeboirts Bosschaert, 1613/14–1654: ein flämischer Nachfolger Van Dycks* (Pictura nova: Studies in 16th and 17th century Flemish Painting and Drawing, 9), Turnhout 2003.

F. Baudouin, 'Het hoogaltaar in de kerk der Geschoeide Karmelieten te Antwerpen, ontworpen door Rubens', in *Essays in Northern European art presented to Egbert Haverkamp-Begemann on his sixtieth birthday*, Utrecht 1983, pp. 26–36.

F. Baudouin, 'Het door Rubens ontworpen hoogaltaar in de kerk der Geschoeide Karmelieten te Antwerpen', *Mededelingen van de Koninklijke Academie voor Wetenschappen, Letteren en Schone Kunsten van België: Klasse der Schone Kunsten* 51 (1991) 1, pp. 22–60.

H. Benesz, 'A painting in the National Museum in Warsaw identified as the Entombment by Abraham Janssens from the Church of the Calced Carmelites in Antwerp', *Oud Holland* 115 (2001/02) 3–4, pp. 200–210.

D. Bieneck, *Gerard Seghers, 1591–1651: Leben und Werk des Antwerpener Historienmalers* (Flämische Maler im Umkreis der grossen Meister, 6), Lingen 1992.

G. Chomer, 'The "Virgo inter Virgines" of Abraham Janssens', *The Burlington Magazine* 121 (1979), pp. 508–511.

J.-B. Descamps, *Voyage pittoresque de la Flandre et du Brabant; avec des Réflexions relativement aux Arts & quelques Gravures*, Paris 1769.

J. de Wit, *De kerken van Antwerpen. Schilderijen, beeldhouwwerken, geschilderde glasramen, enz., in de XVIIIe eeuw beschreven door Jacobus De Wit* (ed. J. de Bosschere) (Uitgaven der Antwerpsche Bibliophilen, 25), Antwerp and The Hague 1910 [1748].

C. Edmond, *L'iconographie carmélitaine dans les anciens Pays-Bas méridionaux* (Koninklijke Academie van België. Klasse der Schone Kunsten. Verhandelingen, coll. in-8°/2nd series 12, no. 5), Brussels 1961.

J.R. Judson, *The Passion of Christ* (Corpus Rubenianum Ludwig Burchard, VI), London 2000.

J.B. de Lezana and P. Wemmers (trans.), *Chronycke en clare bewysinghe van den oorspronck voortganck … van d'orden der heyligher Maghet Maria des Berghs Carmeli*, Antwerp 1666.

T. Meganck, *De kerkelijk architectuur van Wensel Cobergher (1557/61–1634) in het licht van zijn verblijf te Rome* (Verhandelingen van de Koninklijke Academie voor Wetenschappen, Letteren en Schone Kunsten van België: Klasse der Schone Kunsten, 64), Brussels 1998.

Johannes Molanus, *De pictvris et imaginibvs sacris …* Leuven 1570.

R. Oldenbourg, *P.P. Rubens: des Meisters Gemälde* (Klassiker der Kunst in Gesamtausgaben, 5), Stuttgart 1921.

A. Sanderus, *Chorographia sacra Brabantiae: sive Celebrium aliquot in ea provincia abbatiorum, coenobiorum, monasteriorum, ecclesiarum, piarum fundationum descriptio*, vol. 2, The Hague 1727.

D. Steadman, *Abraham van Diepenbeeck, Seventeenth-Century Flemish Painter* (Studies in Baroque Art History, 5), Ann Arbor 1982.

G. Storms, *De schilderijen uit de verdwenen kerk der geschoeide karmelieten van Antwerpen*, unpublished thesis Ghent University, 1987.

B. Timmermans, *Patronen van patronage in het zeventiende-eeuwse Antwerpen: een elite als actor binnen een kunstwereld* (Studies stadsgeschiedenis, 3), Amsterdam 2008.

J. Vander Auwera, 'Conservatieve tendensen in de contrareformatorische kunst. Het geval Abraham Janssen', *De Zeventiende eeuw* 5 (1989) 1, pp. 32–43.

117

Peter Paul Rubens
The Glorification of the Eucharist,
c. 1630? (detail of fig. 104).
The Metropolitan Museum of Art,
New York, inv. 37.160.12

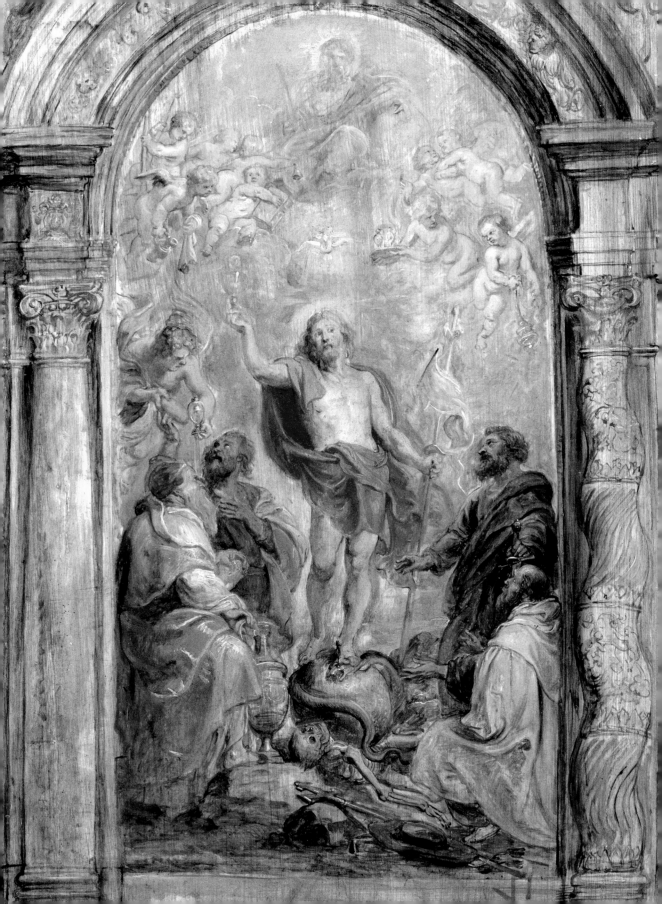

The Church of the Discalced Carmelites

Whenever Rubens entered the delightful garden behind his mansion on the Wapper, he could see the Church of the Discalced Carmelites on the nearby Korenmarkt. The latter, known today as the Graanmarkt, was located to the rear of the Bourlaschouwburg. The monastery stood on a parcel of land called the Lammekensraem, surrounded by Hopland, Meyerstraat and the now-disappeared Papestraat, which continued on from Arenbergstraat. In other words, the church stood on the site of what is now the city theatre. It was accessed via a small courtyard on the east of the Korenmarkt.

History

Work on the church began immediately after the congregation had managed to purchase the building lot between Hopland, Graanmarkt and Vaartstraat. The church was brought into use at the earliest possible moment in 1626, some time before it was actually complete. Archduchess Isabella herself asked the civic authorities to represent her at the inauguration of the buildings. This overt support from the Archduchess made all the difference to win over the City Council and the Chapter of Our Lady's Cathedral who had been reluctant to accept yet another new order in the city. A fraternity devoted to the church's patron, St Joseph, was founded on 20 March 1627. The French revolutionary occupier expelled the friars from the site on 17 December 1796, and the central school of the 'Département des Deux-Nèthes' was installed there the following year. The convent's assets were publicly auctioned between 1799 and 1808, when the complex was turned first into a prison and later into a building depot. In about 1900 the ruins of the church were demolished and in 1968 the Stadsschouwburg (Municipal Theatre) was built on the site.

118

Jacob Harrewijn, after Jacques van Croes
View of the Rubens House, 1692.
Engraving, 330 × 420 mm.
Rubenshuis, Antwerp, inv. RH.P.1114

The roofs and *flèche* of the Discalced Carmelite Church can be seen faintly in the distance.

Building

We have regrettably few details of the
appearance of the Discalced Carmelite
Church, described by the famous Antwerp
historian Amand de Lattin (1880–1959) as one
of the city's loveliest. The convent's archives
were lost during the French occupation, and
other archival and iconographic sources are
119–21 scarce. Fortunately, five plans have survived
124 in the municipal archives, showing the layout
of the building prior to its demolition. Images
93 of the building such as that on Verbiest's city
map of about 1662 show a very simple church
with a plan in the form of a Latin cross.
Another view is part of a late-seventeenth-
122 century album of coloured pen and ink
drawings, which was recently acquired by
Museum Plantin-Moretus, Antwerp. A third,

11 also undated drawing with a view of the
church from the Korenmarkt shows a
building that has two narrow aisles with
hipped roofs reaching up to the clerestory
windows of the nave. The facade only takes
in the nave itself.

The plans, the two most precise of which
date from the late eighteenth and nineteenth
century, confirm that configuration. In
these more recent documents, the church
has a plan in the form of an inscribed cross.
The eastern inner corners of the cross
contained two chapels connected to the
chancel, which was separated from the nave
by a Communion bench. The friars' choir
was located behind the high altar. In so far
as they offer a reliable representation, the
different sources suggest that the church
building came about in several stages.

119

Anonymous
Plan of the 'building depot' on
the premises of the abolished
Discalced Carmelite Convent, 1856.
FelixArchief, Antwerp, inv. 12 5327

120

Anonymous
Plan of the Discalced Carmelite
Convent, before 1796.
FelixArchief, Antwerp, inv. 12 5240

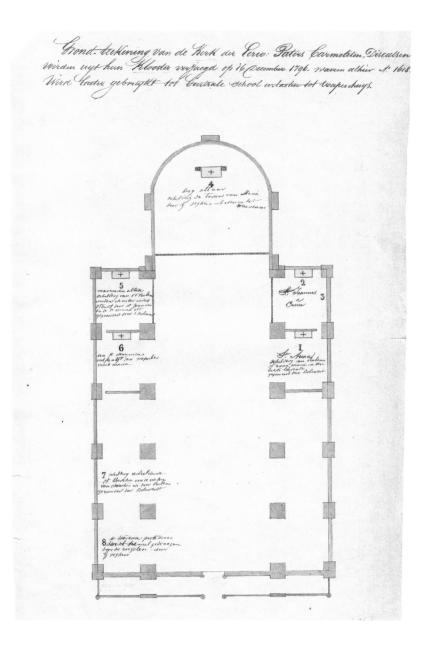

121
Anonymous
Plan of the Discalced Carmelite Church, before 1796.
FelixArchief, Antwerp, inv. 12 5329

In that case, the first two drawings might represent an early stage of construction, without aisles.

Archival information about the building of the church confirms at any rate that work on the fabric continued intermittently for some considerable time. The reason for this was practical in nature: as mendicants, the Discalced Carmelites simply did not have the funds to pay for their church, and so had to call on others to provide the large sums that were needed. In addition to the support of private individuals, they asked the civic authorities for financial assistance. It is from the municipal accounts that we learn that the church must have been unfinished when the city council gave permission for the first services to be held there in 1626, as the accounts show that the construction of the facade was still under way in 1635–36. Municipal subsidies end after 1640. The chronogram above the church entrance

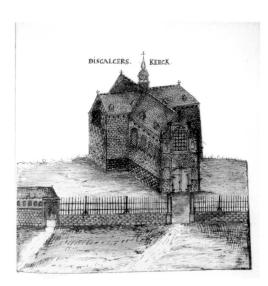

122

Anonymous
The Discalced Carmelite Church.
Drawing from an album with illustrations of Antwerp churches, 17th century?
Museum Plantin-Moretus/Prentenkabinet, Antwerp, inv. s213

mentions the date 1689: *CrUX IoannI LeVe ponDUs teresIae* (The Cross, for John light to bear, for Theresa a boon). The building of this portal will have completed the construction of the facade, and possibly that of the church too.

The churches of 'new' orders, which were founded during the reform of the Catholic Church in the sixteenth century, shared a highly rational architecture that was geared towards rapid expansion. All these monasteries had, after all, to be built from scratch within a short period. That principle also applies to the churches of the Discalced Carmelites in the Southern Netherlands, the floor plans of which display a common structure. This uniformity reflected a 'centralized' construction policy. As was the case with the Jesuits, when a new monastery was to be built, the plans first had to be sent to the heads of the order for approval. The Antwerp foundation belonged to the Italian congregation, so approval had to come from Rome. Sadly, the order's archives in that city do not contain a plan of the Antwerp church, although there is one of its counterpart in Brussels, consecrated in 1612. At first sight, the layout of the church in Antwerp, with its two 'aisles' and chapels on either side of the choir – a basilical plan with inscribed cross – is more reminiscent of the order's contemporary Italian churches, such as Santa Maria della Vittoria (1608–27) in Rome.

However, the background to the construction of the Antwerp church, together with the surviving plan for the one in Brussels, would seem to suggest that the order's construction policy for its first male foundations in the Southern Netherlands still relied heavily on architectural practices in Spain, where the Discalced Carmelites originated. The original structure of the church is, indeed, more likely to have derived to a significant extent from the *traza moderada* ('moderate design'), the outlines of which were drawn up in Madrid in 1600 and

were rooted in the simple medieval monastic building tradition.

The *traza moderada* specified a cruciform church with an aisleless nave affording an unhindered view of the high altar, as was the case with the Jesuits, another 'young' order. The arms of the transept are fairly short – half the width of the nave – but very broad – roughly the same width as the nave. In Antwerp a choir for the friars only, extending from the chancel, was added to this basic layout. It included an altar to the rear of the high altar. The library might have been located above this 'liturgical' choir.

This ideal church model had to meet the needs of a contemplative community, while also enabling the newly founded order to fulfil its pastoral duties in an urban setting. Pastoral care required side-altars to meet the spiritual needs of lay people. The basilical plan of the church in Italy automatically provided 'aisles' consisting of *cappelle passanti* on either side of the nave and connected to one another by doors. There was a parallel tendency, however, within the order's Spanish branch to place the necessary side-chapels in the corners of the choir and of the aisleless nave specified by the *traza moderada*. Various examples of this can be found in the architectural treatise by Andrés de San Miguel (after 1636), himself a Discalced Carmelite friar. This was the solution opted for not only in Brussels but in Antwerp too. While side-chapels were characteristic of the Italian churches of the order, in churches built according to the *traza moderada* specifications, they were an optional feature whose realization depended on local needs and possibilities.

In Antwerp the cruciform plan was inscribed in a rectangle with a view to efficient integration in the rectangular structure of the monastery buildings and connection with its exterior walls. In accordance with the Spanish model, this gave rise to a number of new spaces – 'spare' areas that could be

124
127 C

123

Anonymous
Plan of the Discalced Carmelite Convent in Brussels.
Archivum Generale Ordinis Carmelitarum Discalceatorum, Rome

117

124

Anonymous
Plan of the Discalced Carmelite Church.
FelixArchief, Antwerp, inv. KK 836

readily incorporated in the church as the need arose: when a new private chapel or altar was endowed, for instance. Two private chapels were created in this way next to the choir, and two side-altars were installed against the west walls of the transept in the resultant aisles. A further clue that this was the result of expansion rather than being part of the initial plan is the fact that all these spaces had separate roofs.

It is evident from the detailed plans of the Discalced Carmelite Church in Antwerp that both the aisles next to the choir and those on either side of the nave were nevertheless integrated in the space of the church. This was only partially the case in other foundations such as Brussels, where the equivalent spaces belonged to the monastic buildings or formed part of the walled garden.

The dates of the earliest tombstones might give indication of the period in which these 'spare' areas were incorporated into the Antwerp church building. The earliest epitaph in the north aisle was that of Miguel Gomes Victoria in 1641; that in the south aisle the 1668 epitaph of Maria del Campo y Camera. A view of the church interior painted by Sebastiaen Vrancx in 1647, however, shows the two aisles. Even though the westernmost bay was evidently turned back 90 degrees on both sides in order to offer a more spacious view of the interior, research suggests that this is a faithful depiction and that it may therefore be considered a *terminus ante quem*.

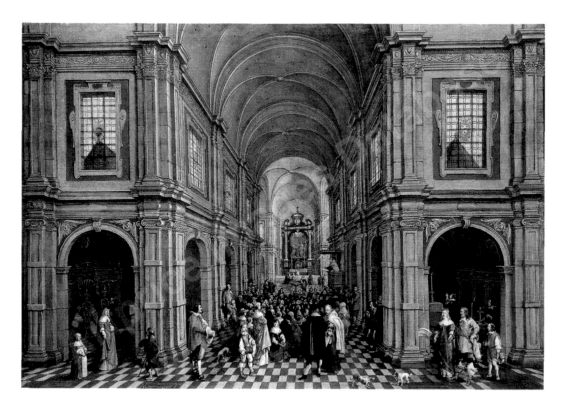

125

Sebastiaen Vrancx
Interior of the Discalced Carmelite Church, 1647.
Canvas, 82 × 118.5 cm.
Private collection

The painting by the Antwerp artist Sebastiaen
Vrancx (1573–1647) is a marvellous witness
to the magnificent interior of the Discalced
Carmelite Church in Antwerp. The work is
signed with the monogram *SV* on the convex
moulding above the capital on the far left and
dated above the first stained-glass window
on the right. The work was only recently
identified by Claire Baisier, based not only on
the robes worn by the friars in the painting,
but above all on its clear depiction of the high
altarpiece.

Unlike the churches discussed earlier,
it was not a work by Rubens that functioned
as central focus here, but another altarpiece
by Gerard Seghers, who painted the one for
the high altar of the Calced Carmelites as
well. The work in question, *The Marriage of
the Virgin*, is now also part of the Koninklijk
Museum collection. It was funded by a
wealthy Portuguese merchant couple,
Manuel Nunes d'Évora and Justa Henriques,
who not only endowed an altarpiece for the
high altar and two paintings for the main
choir, but also fitted out the two side-chapels
on either side of the choir. All this possibly
occurred after their deaths on 8 May 1636 and
8 December 1637 respectively. The execution
of the high altarpiece is in keeping once
again with Seghers's style, heavily influenced
by Rubens from around 1630. Specialists
actually date the creation of this work to
after 1640, viewing it as his most important
achievement in the decade prior to his
death. The death of Rubens in 1640 might
have played a part in Seghers landing this
commission, as well as that for the Calced
Carmelites.

The *Marriage of the Virgin* is a strikingly
serene image, with a harmonious
composition and somewhat modest palette
compared with Rubens's high altarpieces.
This possibly reflects the fact that Seghers

126

Gerard Seghers
The Marriage of the Virgin, before 1651.
Canvas, 510 × 341.5 cm.
Koninklijk Museum voor
Schone Kunsten, Antwerp, inv. 508

Reynolds's note (see fig. 129):
'The altar by Segers/The Virgin and the
atten/dant figures much like/ Rubens,
The St Joseph cold and therefore unlike
one of his best pictures.'

drew inspiration from earlier representations of the theme by the likes of Dürer and Raphael, but also the Discalced Carmelites' strict rules on architecture and interiors. Their *Instructiones* and *Constitutiones* were published in Antwerp in 1631 and 1632 respectively. They set out the order's sober ideals for church building and decoration, and read like barely suppressed criticism of the Antwerp Jesuits' 'marble temple', which had been inaugurated in 1621. While Vrancx's interior shows a church that reflected Italian architecture of the time, the use of materials and the combination of colours are notably austere. The palette consists largely of black and white, with no 'colourful' paintings visible other than the high altarpiece.

The two chapels next to the choir, which were likewise endowed by Nunes d'Évora and Henriques, cannot be seen in the painting either. However, we know from eighteenth-century descriptions of the church that the south chapel – the so-called Chapel of Lights – was their family's private mausoleum. The altar was decorated with another painting by Gerard Seghers showing the *Holy Virgin Presenting the Scapular to St Simon Stock.* The theme of the altarpiece therefore reflected the chapel's funerary function. This was long associated with a work in the Koninklijk Museum collection, although the latter does not match the description of Seghers's painting. The Antwerp municipal archives, by contrast, have an engraving said to have been done after the altarpiece, which is indeed more reminiscent of Seghers's oeuvre. The donors' now-lost commemorative triptych hung opposite the altar. It comprised a central panel with a Crucifixion scene and wings with their portraits, showing them kneeling at prie-dieux incorporating their coats of arms.

The 'dark chapel' on the poorly lit north side opposite was devoted to the Holy Cross. Its altarpiece featured a *Lamentation of Christ*, which eighteenth-century sources state was

128E

130

128F

127

Joris Snaet
Reconstruction drawing of the Discalced Carmelite Church in the 18th century, 2013

A High altar: Seghers,
 Marriage of the Virgin (fig. 126)
B Choir
C Friars' choir
D Transept
E Chapel of Lights (*'licht kapelleken'*)
F Chapel of the Holy Cross
 (*'dark chapel'* – *'donker kapelleken'*)

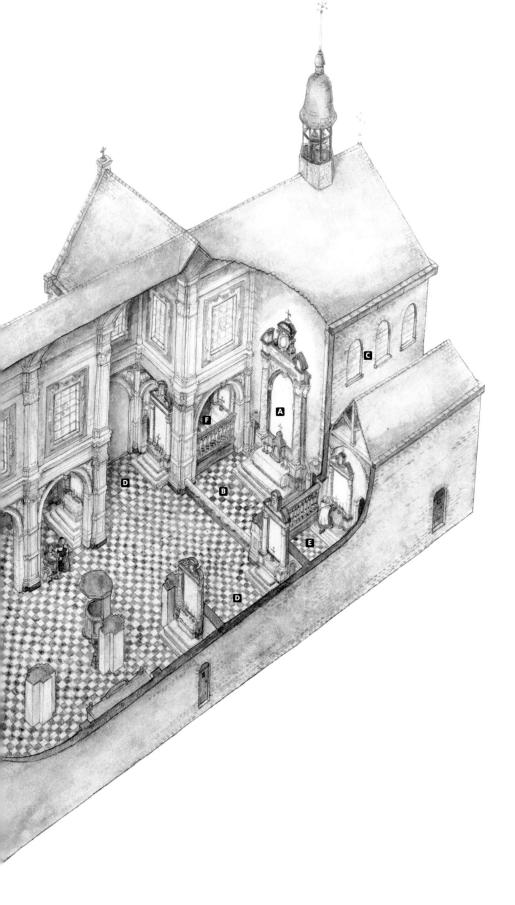

128

Joris Snaet
Reconstruction drawing of the Discalced Carmelite
Church in the 18th century, 2013
(detail of fig. 127)

A High altar: Seghers, *Marriage of the Virgin* (fig. 126)
B Choir
C Friars' choir
D Transept
E Chapel of Lights (*'licht kapelleken'*)
F Chapel of the Holy Cross
 ('dark chapel' – *'donker kapelleken'*)
G Altar of the Fraternity of St Joseph
H Altar of St John of the Cross:
 Pieter Thijs, *Vision of St John of the Cross* (fig. 131)
J Side altar: Rubens, *St Theresa of Avila Interceding
 for Bernardino de Mendoza in Purgatory* (fig. 134)
K Side altar: Rubens, *The Education of Mary* (fig. 136)

painted 'in the manner' of Rubens. Although some claimed it was actually an autograph work of the master himself, there are no further indications that this was the case. We owe an impression of the composition to the zeal of Sir Joshua Reynolds (1723–1792), who sketched remarkable works during a tour he made of the Low Countries.

The altar of the Fraternity of St Joseph, the church's patron, was installed against the east wall of the transept, in the public section of the church, separated from the main choir by a fine marble Communion bench. An inscription on the altar tells us that the marble portico, incorporating a devotional statue of St Joseph, was endowed in 1663 thanks to the generosity of Aleidis Ceurlincx. There is no older altar visible in this spot in Vrancx's 1647 painting.

According to eighteenth-century sources, there was a corresponding altar on the opposite side dedicated to St John of the Cross, the altarpiece of which showed the saint's *Vision*, and which the municipal archivist Pierre Génard (1830–1899) attributed to the Antwerp painter and Rubens collaborator Pieter Thijs (1624–1677). In his vision, St John saw Christ kneeling with his arms around the cross, accompanied by St Theresa, his fellow founder of the Discalced Carmelites, and his name saint, John the Evangelist. God the Father looks down on the scene from the clouds. A statue of the saint surmounted the portico.

Apart from these altarpieces, several other valuable works of art will have caught the eye of visitors to the church. An interesting image of the *Ecstasy of St Theresa* by Gerard Seghers hung in the north aisle in the second half of the eighteenth century. What makes this painting intriguing are the similarities between its composition and the sculpture that Gianlorenzo Bernini (1598–1680) made between 1647 and 1652 for Santa Maria della Vittoria in Rome. This shows that a very similar pictorial tradition existed in the Southern Netherlands – apparently well before

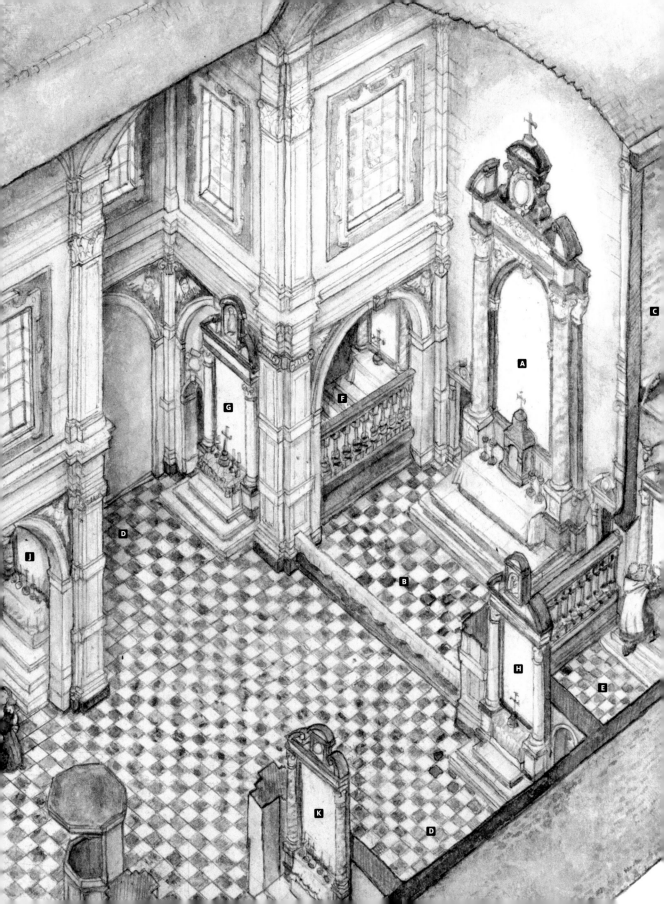

▶ 129
Joshua Reynolds
Sketch after the altarpiece in the 'dark
chapel' and note on the Seghers painting
seen in Antwerp, 1781.
Manuscript notebook. Yale Center for
British Art, New Haven, MS Reynolds 37

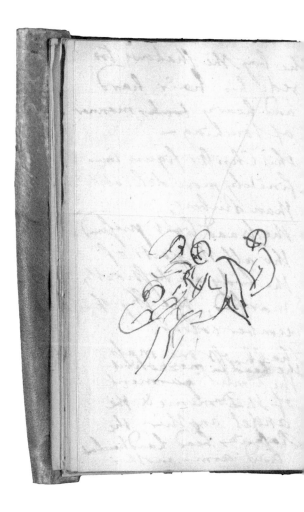

130

Anonymous, after Gerard Seghers's
altarpiece in the Chapel of Lights ('*licht
kapelleken*')
*The Holy Virgin Presenting the Scapular
to St Simon Stock*. Engraving.
FelixArchief, Antwerp, inv. 12 5295

Bernini produced his work – of which
Seghers's painting is the most important
example. Both works depict a seraph that
is about to pierce the saint's heart with an
arrow. Seghers's work might date from the
period 1627–30, which means that it could
– through a copy? – have been a source of
inspiration for the world-famous Roman
sculpture. The painting may originally
have served as an altarpiece elsewhere in
the church, for example in the transept,
as the counterpart to an altar devoted to
St John of the Cross, a configuration we
find in other Discalced Carmelite churches,
including the one in Namur. Two land-
scapes hung in the transept, possibly
below the windows in the north and south
exterior walls.

131

Pieter Thijs
The Vision of St John of the Cross, before 1677.
Canvas, 310 × 175 cm.
Koninklijk Museum voor Schone Kunsten,
Antwerp, inv. 355

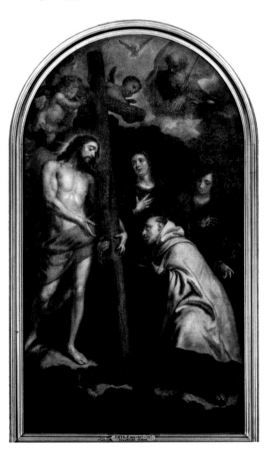

RUBENS'S ALTARPIECES

The Discalced Carmelite Church housed
two works that may certainly be attributed
to the workshop of the 'Apelles of Antwerp'
and which ended up in the Koninklijk
Museum's Rubens collection. They were
not prominently displayed, however, as we
can deduce from Vrancx's painting of the
church interior, in which they are nowhere
to be seen. Both works were the altarpieces
for two small altars located in the would-be
aisles, which are also not visible in Vrancx's
picture. The spaces in question, which were
very poorly lit, measured a mere thirteen
Antwerp feet or just over three and a half
metres in width. The paintings are therefore
modest in size, compared to what we are

132
Titian
*Christ Appearing
to the Virgin*, 1554.
Canvas, 277 × 178 cm.
Chiesa Parrocchiale dell'Assunzione
della Vergine, Medole (Mantua)

133
Peter Paul Rubens
*St Theresa of Avila Interceding for Bernardino
de Mendoza in Purgatory*, c. 1630–35.
Oil sketch: panel, 44.5 × 37 cm.
Museum Wuyts-Van Campen
& Baron Caroly, Lier

used to with Rubens, measuring barely a metre and a half across and about two metres in height. That might well make them the smallest altarpieces Rubens ever painted for free-standing altars.

The reason for this small format cannot have been the limited financial means of the patrons, as one of them – Felipa Mendes Borges – donated up to fifty thousand florins to the monastery, at a time when an altarpiece like this would have cost 'just' a few hundred. It might have been due instead to a more prosaic reason: the limited available space. In Italy, the side-altars in the 'aisles' (or chapels) of the basilica-style floor plan were placed against the exterior walls. This was not customary, however, in the Low Countries and so the altars for which the Rubens paintings were destined were installed against the west walls of the transept which, as we know, was very shallow. There was also an entrance to the transept next to the altar on the north side, which further reduced the available space.

128J The altarpiece on the north side, which was endowed by a wealthy benefactress, showed the order's founder, St Theresa. The scene in which she appears is very

134 unusual. The rare theme, *St Theresa of Avila Interceding for Bernardino de Mendoza in Purgatory*, is an episode from the life of the saint recounted in the tenth chapter of her *Book of Foundations*. Mendoza, a nobleman who was a historian as well as a priest, promised Theresa that he would bequeath her a parcel of land near Valladolid on which to build a convent. He died, however, before he could receive the last sacraments. Theresa therefore prayed to God to take him up into heaven anyway. Christ appeared to her to announce that her prayer had been heard and that her generous donor would be released from Purgatory. The identity of the man being saved is stated by the inscription on the engraving made after the painting.

134

Peter Paul Rubens
St Theresa of Avila Interceding for
Bernardino de Mendoza in Purgatory, c. 1630–35.
Canvas, 196.5 × 142 cm.
Koninklijk Museum voor Schone Kunsten, Antwerp, inv. 299

Rubens places the scene in an indeterminate landscape. The key figures, Jesus and St Theresa, are placed firmly in the foreground, close to the viewer. The resurrected Christ wears a loincloth and a red cloak that leaves his upper body uncovered so we can see the wound in his side. St Theresa, dressed in the habit of her order, kneels at his feet. Rubens clearly drew inspiration for the composition from Titian – more specifically the altarpiece with *Christ Appearing to the Virgin* that he painted in 1554 for the church at Medole near Mantua. Rubens had previously drawn on that work for a version of the *Ecstasy of St Theresa* (now lost) he painted for the Discalced Carmelites in Brussels, and which was more or less a mirror image of the painting under discussion. Just below Christ's feet and Theresa's knees, we see four unfortunates consigned to Purgatory. Shown half-length, the two men and two women are surrounded by flames. One of the two child-angels shown on the left, next to Christ, grips the hand of one of the souls, Bernardino de Mendoza, to lead him out of Purgatory. The woman next to him stretches out her hand to the putto in the hope also of being saved.

Some of the figures were identified in the past in different ways. The eighteenth-century Antwerp historian Jacobus van der Sanden, for instance, reported a local tradition identifying two of them as Rubens and an uncle. For his own part, Van der Sanden recognized two married couples – Rubens and his wife Helena Fourment and Philip Rubens and his wife. The Rubens expert Max Rooses (1839–1914), by contrast, discerned Van Dyck's features in Mendoza, and those of Rubens in the older man. The Wuyts-Van Campen & Baron Caroly Museum in Lier has an oil sketch of the same composition, which might represent a preliminary phase in the design process. This version allows the scene a little more room

132

133

on either side, and there are other, minor differences too, primarily in the poses.

The choice of this unusual theme related to the functions performed by the little chapel. The prospect of salvation offered through St Theresa's intercession will undoubtedly have appealed to the chapel's donor and patron, Felipa Mendes Borges. The place where the scene was displayed was, after all, her own funerary chapel, in which masses would be held for her soul, making the prospect of her own salvation the central focus.

The donatrix belonged to the close-knit circle of wealthy Portuguese bankers and merchants in seventeenth-century Antwerp. They mostly lived in the prosperous parish of St James and traded in luxury goods from the colonies: diamonds, silk, sugar, spices and tobacco. Felipa Mendes must have been a remarkable woman who certainly displayed immense independence of mind. She was married to Simon Dias, a rich diamond trader and consul of the Portuguese community in Antwerp. He does not appear, however, to have wholly appreciated his wife's generosity towards the Discalced Carmelites. A whole series of petitions and legal documents testify to his displeasure at Felipa's munificence. The scale of her donations might have been especially vexing to him. The will she had drawn up on 23 October 1624, several years before her death on 26 January 1629, reveals that she had a fortune of no less than a hundred thousand

135

Historia fundationum Belgicarum Carmel … ab anno 1610 ad annum 1659 …
Rome, Archivum Generale Ordinis Carmelitarum Discalceatorum, AG 103 a

The wealthy Portuguese merchant Simon Dias, who seems to have had reservations about his wife's extravagant benefactions, is called a 'Jewish wolf' in the chronicle of the Discalced Carmelite Convent.

florins. As mentioned above, according to a chronicle of the monastery's foundations, she left forty or fifty thousand of this to the Discalced Carmelites in exchange for masses on her behalf at the altar she had donated. There may, however, have been another reason as well, if Felipa's husband was the same Simão Dias Vaaz who resided in Lange Gasthuisstraat and was included in a list of people suspected in 1630 of continuing to practise Judaism. The wealthy Portuguese merchants in seventeenth-century Antwerp were mostly *conversos* – people of Jewish origin who had been pressured by the Inquisition into converting to Christianity. Contributing to the decoration of a church would have been a conspicuous demonstration of that conversion, on which their fellow townspeople kept a critical eye. Was Simon Dias less than enamoured of his 'new faith'? Or was it the other way around? Did his protests against his wife's substantial donations place him under suspicion? Is it just a coincidence that the convent chronicle uses the phrase *lupus iudeus* ('Jewish wolf') when recording his resistance to his wife's extravagant benefactions?

The eschatological function of the chapel extended further than the personal salvation of its founder. It was also blessed with an extremely important privilege: any deceased person whose relatives requested that a mass be celebrated at this altar in his or her name – something that could happen on a daily basis – would be released from Purgatory,

reflecting the central theme of the altarpiece. We know that the altar enjoyed this privilege thanks to the inscription that was added to it: *altare privilegiatum pro singulis diebus totius anni*. The identity of the donatrix was revealed on a marble commemorative stone installed to the left of the altar portico, also in marble, above a door leading to the transept. This stated that she came from Lusitania, the old Roman name of the region that is now Portugal, and that she not only had the chapel built and fitted out, but also contributed to the completion of the church as a whole.

The work that Rubens's studio provided for the chapel opposite, in the south aisle, showed the *Education of Mary*. Jacob Burckhardt (1818–1897), the famous Swiss cultural historian, wrote that Rubens never painted a lovelier St Anne than the one in this little altarpiece. The scene is located in the open air in front of a balustrade. St Anne tenderly embraces her daughter, who holds an open book. While the adolescent Mary looks at the viewer, her mother's gaze is directed towards two putti who hold a garland of flowers above the unsuspecting girl's head. The older man in the left background is without a doubt Joachim, Mary's father. The theme of the painting has caused a good deal of confusion. Scenes of this kind are normally identified as 'St Anne Teaching Mary to Read', as the Virgin is depicted as a child holding the book. In this case, however, Mary is presented not

128 K

136

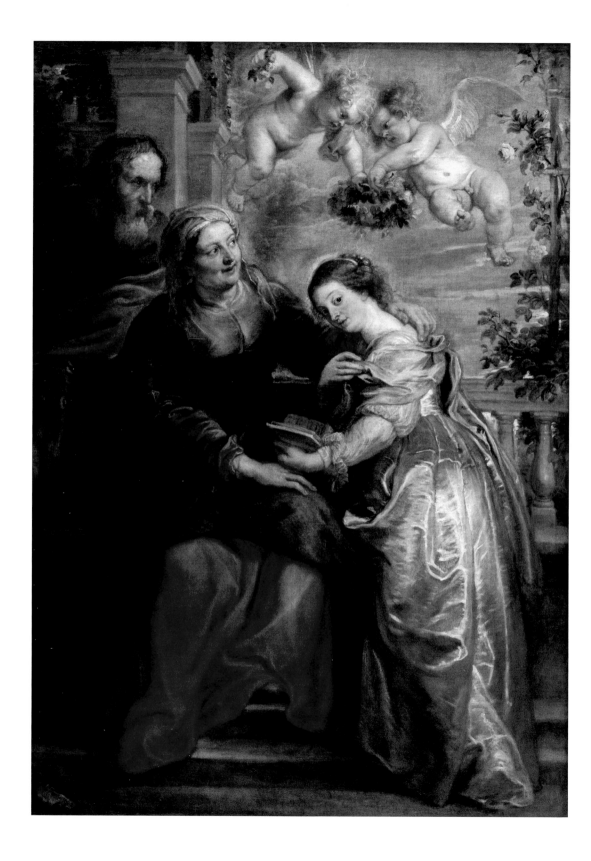

as a child, but as a young woman, making it unlikely that she still needed lessons in reading. Hence the more general description, *The Education of Mary*. We know of several other paintings, incidentally, which confirm this broader interpretation of the theme. Max Rooses detected in the beautiful young woman the features of Rubens's second wife, Helena Fourment.

The patron for this work, unlike that of its counterpart, has not been identified. What we do know, thanks to an inscription on the 'predella', is that it was associated with a charitable fraternity: *altare privilegiatum pro confraternitate charitatis*. What the privilege entailed is not known. Nor is it clear whether devotion to St Anne was linked to the fame of her namesake, the Blessed Anne of St Bartholomew – a Discalced Carmelite nun of Antwerp, who founded the convent on the Rosier. She died on 7 June 1626 and was beatified in 1917. Anne was a close companion of the order's founder, St Theresa, who died in her arms. Tradition has it that the Protestants were prevented from conquering Antwerp on three occasions through the Blessed Anne's intercession, earning her the honorary title 'Liberator of Antwerp'.

136
Peter Paul Rubens
The Education of Mary, c. 1630–35.
Canvas, 194 × 140 cm.
Koninklijk Museum voor Schone Kunsten,
Antwerp, inv. 306

SOURCES

Austin, University of Texas, Benson Latin American Collection, Fray Andrés de San Miguel, Obras de fray Andrés de San Miguel, manuscript, after 1636

Rome, Archivum Generale Carmelitarum Discalceatorum, AG 103 a, *Historia fundationum Belgicarum Carmel: Disc: utriusq sexus Autore R: P: Fr: Dionysio a S. Francisco Belga ab anno 1610 ad annum 1659 ...*

LITERATURE

C. Baisier, 'De documentaire waarde van de Kerkinterieurs van de Antwerpse School in de Spaanse Tijd', unpublished diss. KULeuven, 2008.

C. Baisier and J. Snaet, 'Contrareformatie en barok. Traditie en vernieuwing in de 17de-eeuwse kerkarchitectuur in de Nederlanden', *Gentse Bijdragen tot de interieurgeschiedenis* 33 (2004), pp. 9–38.

G. Berbie, *Beschryvinge van de bezonderste schilderyen ende autaeren, glazen, beeldhouweryen en andere rariteyten welke te zien zyn in de kerken, kloosters ende andere plaetsen binnen Antwerpen ...*, Antwerp 1756.

D. Bieneck, *Gerard Seghers, 1591–1651: Leben und Werk des Antwerpener Historienmalers* (Flämische Maler im Umkreis der grossen Meister, 6), Lingen 1992.

J.-B. Descamps, *La vie des peintres flamands, allemands et hollandais*, Paris 1753–63.

J.-B. Descamps, *Voyage pittoresque de la Flandre et du Brabant; avec des Réflexions relativement aux Arts & quelques Gravures*, Paris 1769.

J. de Wit, *De kerken van Antwerpen. Schilderijen, beeldhouwwerken, geschilderde glasramen, enz., in de XVIIIe eeuw beschreven door Jacobus De Wit* (ed. J. de Bosschere) (Uitgaven der Antwerpsche Bibliophilen, 25), Antwerp and The Hague 1910 [1748].

J.C. Diercxsens, *Antverpia Christo nascens et crescens, seu: Acta ecclesiam Antverpiensem ejusque apostolos ac viros pietate conspicuos concernentia usque ad seculum XVIII*, vol. 7, 1773.

C. Edmond, *L'iconographie Carmélitaine dans les anciens Pays-Bas méridionaux* (Koninklijke Academie van België. Klasse der Schone Kunsten. Verhandelingen, coll. in-8°/2nd series 12, no. 5), Brussels 1961.

Gilles, 'Les Carmes-déchaussées. À propos de la démolition des bâtiments de l'Arsenal', *La presse*, 2 February 1908.

C. Göttler, *Die Kunst des Fegefeuers nach der Reformation: Kirchliche Schenkungen, Ablass und Almosen in Antwerpen und Bologna um 1600* (Berliner Schriften zur Kunst, 7), Mainz 1996.

C. Göttler, 'Securing Space in a Foreign Place: Peter Paul Rubens's Saint Theresa for the Portuguese Bankers in Antwerp', *Journal of the Walters Art Gallery* (1999) 57, pp. 133–51.

C. Göttler, 'Religiöse Stiftungen als Dissimulation? Die Kapellen der portugieschen Kaufleute in Antwerpen', in W.E. Wagner (ed.), *Stiftungen und Stiftungswirklichkeiten. Vom Mittelalter bis zur Gegenwart*, Berlin 2000, pp. 277–305.

A. de Lattin, *Evoluties van het Antwerpsche stadsbeeld: geschiedkundige kronijken*, vol. 3, Antwerp 1943.

A. Monballieu, 'Het probleem van het "portret" bij Rubens' altaarstukken', *Gentse bijdragen tot de kunstgeschiedenis* 24 (1976–78), pp. 159–68.

J. van den Nieuwenhuizen, 'Antwerpse schilderijen te Parijs (1794–1815)', *Antwerpen: Tijdschrift der Stad Antwerpen* 8 (1962), 2, pp. 66–83.

C. Piot, *Rapport à Mr le Ministre de l'Intérieur sur les tableaux enlevés à la Belgique en 1794 et restitués en 1815*, Brussels 1883.

F. Prims, *Geschiedenis van Antwerpen*, 6B, Brussels 1982 (reprint).

S. Sturm, *L'architettura dei carmelitani Scalzi in età barocca. Principi, norme e tipologie in Europa e nel Nuovo Mondo* (Roma storia, cultura immagine, 15), Rome 2002.

B. Timmermans, *Patronen van patronage in het zeventiende-eeuwse Antwerpen: een elite als actor binnen een kunstwereld* (Studies stadsgeschiedenis, 3), Amsterdam 2008.

L. Verdú Berganza, La 'arquitectura carmelitana' y sus principales ejemplos en Madrid, unpublished diss. Universidad Complutense Madrid, 1996.

H. Vlieghe, *Saints* (Corpus Rubenianum Ludwig Burchard, VIII), Brussels, London and New York 1972–73.

J.C. Weyerman, *De levens-beschryvingen der nederlandsche Konst-schilders en Konst-schilderessen, met een uytbreyding over de schilder-konst der Ouden*, The Hague 1729.

137
Peter Paul Rubens
St Theresa of Avila Interceding for
Bernardino de Mendoza in Purgatory, c. 1630–35
(detail of fig. 134).
Koninklijk Museum voor Schone Kunsten, Antwerp, inv. 299

Page numbers in italics refer to illustrations.

PHOTOGRAPHIC ACKNOWLEDGEMENTS

Claire Baisier fig. 11
Karin Borghouts fig. 1
Christie's, London figs. 86, 90
Detroit Institute of Arts fig. 70
FelixArchief, Antwerp figs. 4, 10, 14, 29,
 33, 76, 93, 96, 98, 100, 107, 108, 112,
 113, 119, 120, 130
Valérie Herremans figs. 15–17, 28, 60,
 63, 64, 66, 71, 74, 75, 80, 94, 95, 99,
 121–124, 135
Jheronimus Bosch Art Center,
 's-Hertogenbosch fig. 62
KIK/IRPA, Brussels figs. 44–47, 52, 53,
 77–79, 91, 103, 106, 109–111, 126, 133
King Baudouin Foundation, Coll.
 Charles Van Herck, on permanent
 loan to Museum Plantin-Moretus/
 Prentenkabinet, Antwerp figs. 9, 35
Kunsthaus Lempertz, Cologne fig. 125
Lukas – Art in Flanders vzw / Koninklijk
 Museum voor Schone Kunsten,
 Antwerp, photo Hugo Maertens
 cover, frontispiece, p. 6; figs. 2, 3, 7, 12,
 19–27, 30, 31, 34, 36–43, 69, 72, 73, 87,
 92, 114–116, 131, 134, 136
The Metropolitan Museum of Art,
 New York 104, 117

Musées royaux des Beaux-Arts de
 Belgique/Koninklijke Musea voor
 Schone Kunsten van België, Brussels
 fig. 32
Musée de Grenoble fig. 68
Museum Boijmans Van Beuningen,
 Rotterdam fig. 101
Museum Plantin-Moretus/Prentenkabinet,
 Antwerp figs. 13, 48, 51, 97
Muzeum Narodowe, Warsaw fig. 8
Nationalmuseet, Copenhagen fig. 89
Réunion des Musées Nationaux, Paris fig. 5
Rijksbureau voor Kunsthistorische
 Documentatie, The Hague figs. 57, 58
Rijksdienst voor het Cultureel Erfgoed,
 Amersfoort fig. 81
Rijksmuseum, Amsterdam fig. 65
Rubens Online fig. 105
Rubenshuis, Antwerp fig. 118
Joris Snaet figs. 18, 56, 59, 102, 127, 128
The Trustees of The British Museum fig. 6
UC Berkeley Art Museum fig. 85
Adri Verburg figs. 49, 50, 54, 55, 61, 67,
 82–84
The Wallace Collection, London fig. 88
Yale Center for British Art, New Haven
 fig. 129